YIELD

YIELD
The Journal of an Artist

Anne Truitt

Foreword by
Rachel Kushner

Edited by
Alexandra Truitt

YALE UNIVERSITY PRESS New Haven and London

28 January

"Crouching Tiger, Hidden Dragon" is a movie ~~recently~~ made in China. Yo Yo Ma's cello ~~~~ lifts ~~the music~~ into ~~articulacy~~ ~~a~~ ~~~~. The film's theme: the discipline ~~~~ of love restrained by ~~dignity~~ wisdom and ~~~~ force. Trained by martial arts. ~~Spirit~~ True love and true desire, ~~~~ true spirit and ~~~~ strong body, are ~~~~ by ancient disciplines, ~~~~ point and sword edge. The ancient ~~~~ sword is ~~~~ a ~~product~~ of ~~~~ discipline. The blade ~~~~ ~~~~ embroces, ~~~~ ~~~~ This intaglio ~~~~ ~~~~ catches the blood ~~~~ so cuts smoothly ~~~~ into a rut of a body, and cuts another fact. Men & women are ~~~~ ~~~~ rendered equal by force of ~~training~~ ~~~~ character ~~~~ by training ~~~~ this ~~~~ ~~~~ just as they are in art.

~~Ever since~~ I saw ~~~~ the ~~~~ ~~~~ (installed age) ~~~~ I will watch China, and ~~~~ ~~~~ Chinese ~~~~ now ~~~~ ~~~~ of my lifetime ~~~~ by violence,

A page from Anne Truitt's notebook, January 28, 2001

PREFACE
Alexandra Truitt

In the spring of 1974, after retrospective exhibitions of her sculpture and drawings at the Whitney Museum of American Art in New York and the Corcoran Gallery of Art in Washington, DC, Anne Truitt committed herself to keeping a journal for a year. She would continue the practice, sometimes intermittently, over the next six years, writing in spiral-bound notebooks and setting herself no guidelines other than to "let the artist speak." These notebooks, written from summer 1974 to summer 1980, were compiled and published in 1982 as *Daybook: The Journal of an Artist*. Two other volumes followed: *Turn*, in 1986, which drew from journals kept from summer 1982 to winter 1984, and *Prospect*, in 1996, based on journals from spring 1991 to spring 1992.

This book—the final volume of Truitt's journals—collects entries she wrote from the winter of 2001 to the spring of 2002, two years before her death.

For her first three books, Truitt's editorial process was to record herself reading the handwritten journals aloud, often revising as she spoke. These recordings would then be professionally transcribed, resulting in preliminary manuscripts that she would continue to polish while working closely with Nan Graham, her editor at Scribner.

No transcription of the material that would become *Yield* was undertaken during her lifetime. When I visited my mother during her autumn 2001 residency at Yaddo, the artists' retreat in Saratoga Springs, New York, she mentioned that she had started to record some of her recent writing but decided to

devote her time and energy to the studio instead. For the remainder of her time there, and until her death in December 2004, she would focus on her *Pith* paintings, her sculptures, and two new series of works on paper. She continued writing in her journal until April 2002, but, in deciding to set aside the task of recording, transcribing, and editing this material, she very likely understood that it would not be published during her lifetime.

The decision to initiate a transcription of the 2001–2 notebooks was made while I was researching and compiling Truitt's unpublished texts (correspondence, talks, interviews, lectures, artist statements) with the goal of preparing a volume of selected writings. During this process, it became clear to me that these notebooks were similar in style and tone to the three published journals. Indeed, in the autumn of 2004, my mother told me she had written a "fourth book." During my initial reading of the notebooks, I was encouraged to find the following three entries in which she clarifies her evolving intentions: "This writing I am doing might actually become another book. If so, good. If not, good" (February 17, 2001); "If a book, the title is *YIELD*" (April 7, 2001); "This writing is *Yield: A Working Journal*. Limited. Continuing. Will turn into a manuscript but not publish unless my working life comes to an end" (February 11, 2002).

While transcribing these journal entries, which are heavily annotated and occasionally difficult to decipher, I kept in mind the discussions I'd had with my mother about her writing over the years, and I visited the Anne Truitt Papers at Bryn Mawr, where I familiarized myself with her early drafts of *Daybook, Turn,* and *Prospect.* I also made use of the partial recording she made at Yaddo in 2001, which, while not definitive or comprehensive, was often illuminating. What few editorial interventions were

made to what would become the manuscript for this book were carefully considered. Several passages were shortened to avoid repetition or were eliminated because they required context that only Truitt could have provided. A few entries about our family were also left out. As meaningful as these passages may be to myself and other members of the Truitt family, they would have been of little significance to general readers. And even without these more familial entries, the importance of her family life, including her affection for all her children and grandchildren, remains abundantly clear.

Readers who are familiar with the first three journals will find in *Yield* the same deft and lucent prose that made those earlier books so affecting; they may also notice that parts of *Yield* have a somewhat fragmentary feel in comparison to those earlier publications. Truitt's decision to think of this volume as "a working journal," in this way differentiating it from her previous journals, I think speaks to this difference.

In all of her books, Truitt recounts not only her life as an artist but also her placement in the world, literally and met-aphorically. *Daybook* opens with a description of flying over a desert in Arizona; *Turn* begins at a cottage on Bethany Beach in Delaware; and the preface of *Prospect* recounts Sir Ernest Shackleton's famous expedition across the Southern Ocean in 1916. In *Yield,* however, Truitt proceeds from a place of interi-ority. She observes, "The validity of the world we find ourselves living in has its origin in the uniformity of our nervous and sensory systems, not in its intrinsic objectivity."

The text explores territory familiar to readers of her other books. Truitt writes openly about her studio practice, her family, and a cadre of old friends: the anthropologist and artist Tobias Schneebaum; Cord Meyer, whom she met not in his capacity as a CIA official but as the husband of her fellow

artist Mary Pinchot Meyer; Cicely Angleton, whom she also met through Mary Meyer, and whose husband was James Jesus Angleton, chief of counterintelligence for the CIA from the late 1950s to early 1970s; and Katharine Graham, publisher of the *Washington Post*. She shares her personal experiences of Helen Frankenthaler, Robert Motherwell, Martin Puryear, David Smith, and other artists, as well as thoughts on Donald Judd, Jackson Pollock, Marcel Proust, Sun Tzu, Napoleon, Lafcadio Hearn, Japan's Living National Treasures, the environment, genetics, gender and equality, Bob Kerrey, 9/11, the George W. Bush presidency, and America's changing place in the world.

In *Yield,* with the same unflinching and characteristic honesty of the other volumes, Truitt articulates and comes to terms with the intellectual, practical, emotional, moral, and spiritual issues that an artist faces when reconciling her art with her life, even as that life approaches its end. Truitt illuminates for us a life and career in which the demands, responsibilities, and rewards of family, friends, motherhood, and grandmotherhood are ultimately accepted, together with those of a working artist.

FOREWORD:
A WIND THAT SOMEHOW INCLUDED ME
Rachel Kushner

"We are and we are not," Anne Truitt wrote in her journal on December 10, 2001. She was quoting Heraclitus on presence and vanishing, the constant flow of change. Anne Truitt was, and is no longer. I am and will no longer be. Everything will depart and the world will remain, and we are of the world, and so something of us remains, too. I don't mean in the form of sculptures and journals and books, but something intangible, like the end of the rainbow that Truitt recalls seeing as a young girl, see-through colors cast upon the ground.

Still. With these journals, we continue to have the daily observations of an artist at the end of a long and productive and steadfast life, even as her vigor, as she says, no longer underwrites her will. I have read *Yield* both out of curiosity about Truitt and her life, and for more selfish reasons: I wanted to know, at my age—right now, fifty-two—how to live, by drawing from the wisdom and determinations of a woman at age eighty. I was looking for hygiene, perhaps, of a particular kind: in thought and habits, in temperament and mood. I wanted instructions, silly as that might sound, for parsing the world with care, and honoring my own life.

"Every day a page is turned," Truitt says of the Gutenberg Bible in a library vitrine. A daily journal is only for the diligent. A strange document. It records what you later won't remember of the details of the day. So much passes through the sieve of consciousness and into oblivion, and yet it is what we are: a succession of days. What we do remember naturally, without writing it down, is shaped into a category Proust calls

"voluntary"—memories we mull and rework, sometimes into myth. A diary, instead, can be a sort of camera, snapping pictures of things you would otherwise not be able to later see.

To read Truitt's diary shows me what she thinks about without a mannered or false layer of retrospective presentation. How she orders work and friends and ethics and stillness. The ways in which she values her own life. I think of my mother saying to me just the other day, with humor but also gravity, "Too bad we don't get to do this twice." It goes fast. I want to cherish it. So did Anne Truitt. That doesn't mean she was perfect, even as she seems to have been motivated by great purpose, and by restraint and routine. There are accounts of sadness and regret, a dream about a lonely child; a phone call where she senses she is being a bully. Darker thoughts—for instance, a murdered friend. The violence of the real ("Actuality mocks art," she says of 9/11, a horror followed by the horror of nationalism and war). There are thoughts on Yeats, Sun Tzu, her own sculptures. And fun cameos, remembered or recorded: vodka martinis with Clement Greenberg. Thrifting with Jem Cohen. A conversation with Duchamp at the Institute of Contemporary Arts in Washington, DC. And meanwhile, insights both minor and grand. So few artists, she says, have the strength to afford tenderness. And images, such as her description of the scene from Bergman's *Wild Strawberries* in which the protagonist's long-dead parents wave from across a river inlet: the permanence of a memory, a moment in which an old man is a boy, love is eternal, and, as Truitt says elsewhere, "the past folds into the present."

"Our deepest intimacy is that which trues us on a spiritual plumb line," she writes. And elsewhere: "I looked 'out' and saw something that matched what I already knew to be true." On a farm in Virginia, her aunt taught her to take pleasure in

the daily. This seems to have gone a very long way. Of her turn to art: it one day occurred to her "that if I made a sculpture it would just stand there and time would roll over its head and the light would come and the light would go and it would be continuously revealed." Near the end, both of these journals and of Truitt's life, she writes of the "feeling of prairie grasses rising and falling, sweeping and twisting, in a wind that somehow included me."

The wind included her. And she, it.

To parse the external world with care, and to honor your own interior life: perhaps these finally merge in some union where they are, or always were, the same thing.

YIELD

Should I call this book a novel? It is something less, perhaps, and yet much more, the very essence of my life, with nothing extraneous added, as it developed through a long period of wretchedness. This book of mine has not been manufactured: it has been garnered.

Marcel Proust

Each individual lives the story of his or her own existence—we "translate" our lives as we live them. In my case translated into objects: art and books.

Anne Truitt

Winter

The validity of the world we find ourselves living in has its origin in the uniformity of our nervous and sensory systems, not in its intrinsic objectivity. Rather mechanically—like ants or earthworms—we act and react within a context we individually make up as we go. The coordinates of time and space, warp and woof, keep us in a general pattern of order. Yet minute differences in our physical setups make agreement essentially virtual, inexact, resulting inevitably in disorder on a scale from disquiet to war. And all is moving all the time, as if breathing.

I do not like to feel that I am making up as I go the world I live in. I would like to turn back to the world I have taken for granted until now. A solid world to which I could confidently try to adjust by practicing various ways of looking at it, coordinating its variety, by way of observation and logic. A world that offered me the hope that I might, if I made the effort, increase my understanding of it. Now, slowly and reluctantly, my mind, sadly, has dragged me to a point inside myself at which the world peters out into nothingness. Leaving "me" without perimeters or parameters, and forcing me to postulate that "I" am inventing what "I" live.

January 15

In two months and one day I will have lived on the earth for eighty years. The body that piled pillows prop up in bed on this misty still-dark morning is wicker. An animated arrangement of twigs, kept orderly and useful by respect and care. Orderly and useful and obedient to a conviction that I have not finished

specific tasks that I seem to myself to have undertaken when I got born. Four sculptures are in the making in my studio. I intend to complete their undercoating within a week. I miss the vigor, the smooth sweet flow of muscular strength, the utter readiness with which I used to underwrite my will. Only two steps up on my ladder now, and only one ladder instead of three, and those two steps thought out in advance. I fear falling.

Lafcadio Hearn tells of the Buddhist priest Kōbōdaishi:

> When he was in China, the name of a certain room in the palace of the Emperor having become effaced by time, the Emperor sent for him and bade him write the name anew.
>
> Thereupon Kōbōdaishi took a brush in his right hand, and a brush in his left, and one brush between the toes of his left foot, and another between the toes of his right, and one in his mouth also; and with those five brushes, so holding them, he limned the characters upon the wall. And the characters were beautiful beyond any that had ever been seen in China—smooth-flowing as the ripples in the current of a river. And Kōbōdaishi then took a brush, and with it from a distance spattered drops of ink upon the wall; and the drops as they fell became transformed and turned into beautiful characters.[1]

When I was living in Japan, I occasionally saw a Japanese conversation stop in midair until a character, apparently clarifying meaning, was quickly sketched on one conversant's palm and looked at by the other.

This interchange had vigor and grace, immediacy, personality. No computer could replicate the particular movement. Something personal will be lost in the landscape of the computer, too vast and flat for this flavorful an event.

Art is above and beyond skill. A poetic truth. Skill takes an artist a certain distance, but it is only beyond skill that art springs forth. I like calling scientific concepts designated by certain specific interacting strokes of a brush a "character."

An article in the *New York Times* tells of Li You, a twenty-three-year-old who lives in southern China, in Guanzi province, in rural Yangshuo. About six years ago he started using a computer, whereupon the Chinese characters he had learned to write in childhood began slipping away.[2] The delicate strokes now scramble themselves and his pen falters in his hand. But then, he now almost never picks up a pen. A pity, a seepage of self-expression.

January 16

The meaning borne by a calligraphic character must lance instantaneously into the mind. A succinct message bearing at a glance the complexity of an idea in a delightfully compact package. A package made by hand too, the élan of that hand enlivening every stroke, personally inflecting the meaning of the whole.

I have stood transfixed by calligraphic scrolls inscribed by masters, understanding nothing and everything, save the power of the hand. The power of the hand is immediate. Had Jacques-Louis David not drawn Marie Antoinette sitting perfectly erect in the tumbril on her way to the guillotine, the once-elaborate flowered towers of her hair reduced to lank string hanging on either side of her mute face, we would not understand her so well. Nor him. Yet he had voted for her death.

January 17

An art historian commenting on an early Frank Stella: "What he would like more than anything else is to paint like Velazquez. But what he knows is that that is an option that is not open to him. So he paints stripes. He wants to be Velazquez so he paints stripes."[3] Attribution of motive always bothers me: any person attributing motive to another person has prepared a Procrustean bed and has the axe ready. I do not know what Frank Stella sees or feels when he looks at a Velazquez painting. I do not know that he "would like more than anything else to paint like Velazquez."

I do know what I see in *Las Meninas.* I see the open door in the background without the figure in it. I feel in the very paint itself the room's space: dusty, dark, and so immense that the people in it are rendered anecdotal. As, by implication, we human beings are incidental to the space and time into which we have been born.

To "paint like Velazquez" does not mean to me to make a painting that looks like his. It means to tell the truth as strictly as Velazquez does. Stella's stripes do. Critics who attribute nostalgia to artists reveal its allure in themselves. Honest artists scorn sentimentality. Artists who entertain nostalgia weaken themselves. Nostalgia: from the Greek *nostos,* home, and *algia,* pain. To be exiled is honorable. To be sentimental is not.

Homesickness is different. *Heimweh,* home-way, in German. The French have no word for it.

January 18

I took to going my own independent way when growing up. Only rarely now am I astonished by what goes on outside me;

I am more often astonished by what goes on independent of me inside me. Just a few minutes ago, a way I've not thought of before of lifting color into autonomy just popped whole into my inner eye. A method depending on what I know about materials, naturally, but one actually depending on what I learned in a high-ceilinged, wide-windowed, plain classroom at Bryn Mawr during my first year of college. And perhaps owing to my recent preoccupation with *Las Meninas.*

January 19

A series of paintings that I began at Yaddo in October 1999 still haunts me. And eludes me. A few inches by a few inches to six foot by six foot. All dark. But just when I had decided to jettison them all, a permutation thrusts itself forward: the space splits.

And then I remembered the black-barked cryptomeria trees at the Ise shrine in Japan: straight, strong lines, how they started up out of the ground, at my feet, and ended way up high in leaves so dense that black met black.

For some years I have known that the hippocampus mediates human memory. I somehow got the idea it was a pea-shaped structure embedded in the brain stem. But not at all. The word derives from the Greek: *hippos,* horse + *campos,* sea monster = seahorse. Webster defines it as a curved, elongated ridge extending over the floor of the descending horn of each lateral ventricle of the brain. The idea of my memory being dependent on a seahorse-shaped ridge clamped on two horns in my head makes me uneasy; the pea seemed innocent.

The names of people are elusive now. I wait for them to materialize, as if for a computer to write them on a screen. The names of things, too, sometimes lag in my throat.

People my age tend to be impressed by what they do not remember. I am more impressed by what I do, which is every single experience that some magnet in me has retained—laid down as if it were compost for the future. The experience on which I depend for living and for work remains perfectly immediate, and I like living in a world unnamed.

January 20

A new president of the United States, George Walker Bush, will be inaugurated today. I disagree with him on every civic, political, and psychological issue. I am anxious for the country. But turn and turnabout is fair play. A medieval day: dire dark clouds, pierced by needles of rain, press down upon the city, chill body and mind. Fear abroad in the land?

January 21

I plan to make oatmeal cookies with raisins this morning, Alexandra's favorite. She arrives the day after tomorrow at noon; Mary and Isabelle, her fifth and youngest child, in the late afternoon.

* * *

Not just this morning—all day. I got tired, had to stop and nap. Simply left the oven on . . .

January 23

President Bush's very first official act was an executive order to ban federal aid to overseas groups that provide abortion counseling.

His second act was to attend the swearing in of his staff and to state his standards for their conduct: they are not only to *watch* one another for any illegal act but also to *report* on one another, "even on me," the president said. Unctuously.

I feel more than anxious, fearful. Cast back to the 1950s, the McCarthy era during which a citizen could be indicted for holding certain intellectual convictions.

Living in Washington as I mostly have since 1947 has made me sensitive to sitting presidents.

I do not trust my new neighbor.

January 25

Isabelle is sturdy, self-possessed, and looks like her mother Mary. Ask her her age and she says, "one." More toast? "Yes," and after a moment, "Please." She ate a hearty dinner, in her high chair drawn up to the candlelit table, in the company of her aunt, mother, and grandmother. Then her bath. Into her orange-red striped pajamas. Hugs all around and into her crib from which she lifted her head twelve hours later with a smile.

She and her mother departed this morning in a flutter of color; Alexandra chipped the ice off the front steps; I turned the heat up in the studio; ran my eye over the paintings stacked; cooked lunch and set the table in the sunshine. Renato Danese from my gallery in New York arrived. We are planning an exhibition to open on February 15. A protégé of Walter Hopps, I met him in 1967 when he was a graduate

student—about twenty-five, a vibrant young man in a blue-and-white striped shirt. He curated an exhibition of my *Arundel* paintings at the Baltimore Museum of Art in the '70s, worked at the National Endowment for the Arts, in Los Angeles, and at the Pace Gallery in New York for some years. In 1996, when André Emmerich, with whom I had shown since 1963, sold his gallery to Sotheby's, Renato became an independent dealer and, with due thought and care, I moved under his aegis. While he was working at the NEA he had lived next door. Our dogs used to play together, and my children and he are friends too. So his presence in this house again was a special pleasure.

After lunch, we sorted through the paintings. The exhibition fell, as if inevitably, into place.

January 26

A perfectly quiet day, alone.

January 27

A quartermaster day: the schedule of the exhibition discussed; train reservations made; letters written; telephone calls back and forth. No work today as the paintings fill the studio, those chosen for the exhibition—they depart for New York next Tuesday.

January 28

Crouching Tiger, Hidden Dragon is a movie recently made in China. Yo-Yo Ma's cello refracts the film's theme: the discipline of love

restrained by wisdom and force by martial arts. An ancient sword is a protagonist—itself a product of discipline. Its intricately incised intaglio catches blood so the sword can smoothly slide into and out of a body, and into another, fast.

January 30

My memory is long. I don't know anyone else who remembers being born. I wish I did so we could compare notes. My mother said that my birth was an easy one, but even so it was a shock to be pressed so close and then burst out so fast. Everything that had been soft turned sharp: piercing light and clatter in a fearsome rush. Birth is eruption. A core could have splintered but did not.

Until my twin sisters were born eighteen months later, I lived in the nursery of the third floor of our house in Easton, Maryland. I remember lying in my crib: white-painted iron with knobby railings cut what I saw into vertical stripes of space. The nursery had a low ceiling. I remember warm light and creamy air and, above all, quiet.

Sometimes on my back looking at the ceiling, a slow, strong riptide would pull "me" up from my toes or down out of my toes. My soft body would be galvanized: a relentless force. I remember the tide as colored gold.

This experience got to be rare and finally stopped. I remember being relieved.

Last night I woke out of a shallow sleep into the same pull—up this time—and I recognized the tide.

February 3

February is my favorite month. One of the paintings in the coming exhibition is *Februae*—Latin, to cleanse.

I have a cold. Time-out. I am rereading Josephine Tey's *The Franchise Affair* and eating homemade vegetable soup with crackers.

February 7

When just arrived in Japan, at the age of forty, in April 1890—I was to arrive there at the age of forty three, seventy-four years later, in April 1964—Lafcadio Hearn, newly arrived, asks why worshippers clap their hands when entering places of worship. He is told that this act awakens the devotee. "All beings are only dreaming in this fleeting world of unhappiness." To pray is to wake up.[4]

When still new to the land Hearn enters a particular Buddhist temple, and an ancient priest leads him through a series of screens that stretch from floor to ceiling, opening into ever-darker, ever-more-inner spaces. "I reach the altar, gropingly, unable yet to distinguish forms clearly. [. . .] I look for the image of the Deity [. . .] and I see—only a mirror, a round, pale disc of polished metal, and my own face therein, and behind this mockery of me a phantom of the far sea." To pray is to see oneself.[5]

Hearn asks himself why Japanese trees are irresistible. I too, as I wound through the narrow twisting alleys of Tokyo. I would go out of my way to look again at a black branch hung with round, orange, ripe persimmons just visible over an old stone wall. Not everyone appreciated this detail. I led Clement Greenberg to that very branch; he glanced at it dismissively and said nothing.

One afternoon, walking home from my studio in Bunkyo-ku to our house in Shinjuku, I saw toward the east a tall leafy tree, recognized that under it would be a Shinto shrine, and thus discovered the tiny dark altar that became my own, a comfort to me. Two small stone foxes, as crude, lichened, and weathered as if protruding out of the earth itself, guarded this sacred place: fox—the god Inari, leftover from the country village Tokyo once was. Inari is dear to me, akin to Jizo who watches over children, into whose kimono sleeves they creep as they die. I have an old, worn-smooth Jizo on the mantle in my living room. And I can see from my bed on top of my bookcase the little scarlet and black *torii* I bought for Sam at the Inari shrine in Yoshiwara.

February 8

My deepest satisfaction now is entering into the inheritance of my own life. A realm over which time has no sway.

I wander and stop and stay here and there:

To look carefully at the proportions of the dark-green-painted door of my nursery, a rectangular pattern, a perfect order, set off by a round, shining, brass doorknob. So small that fairly soon in my life it fit my hand.

To breathe the mist that surges up from Partington Cove to reach our house on Partington Ridge in Big Sur. To wake up in the middle of the night there out on the porch where I liked to sleep. The porch hung out over Partington Canyon, through which, before dawn, fog flowed from the Pacific Ocean so that the canyon disappeared and I lay between a cloud and a dark, starred sky.

To smell my babies when they were first born, the most intimate of all smells. To look into their faces, and into their eyes, to seek and find.

February 10

I am becoming "one acquainted with the night." Robert Frost—a name like a ship's mast—stands tall against the dark. I do not. Ghosts visit me in my dreams. Death has not improved them. Last night one so mean that I fought to remember that I was asleep even as I struggled to wake up. Even when I did, the ghost kept right on talking, indifferent, self-centered. His point of view is a point, sharp, admitting no other. I have on my black coat, the one that I will wear to New York next week and "hold my own." But I seem to have no "own" to hold. I feel killed. And the worst of it is that that person did "in real life" kill me. I just walk around anyway.

Last night I went downstairs and ironed a pile of clothes.

February 11

Cord Meyer was born in November 1920, his wife Mary Pinchot Meyer in October 1920, James Truitt in June 1921, and I in March 1921. We were all in utero together, aligned in a short stretch of time. Time is running out on Cord, stripped to his skeleton by cancer. One of his eyes was blasted out of his face on an island in the Pacific during World War II. His twin brother, also a marine officer, was killed on another of those islands. One of his sons was killed by a car. Mary Meyer was murdered.

But Cord is still Cord. This afternoon I looked into his one eye, and he looked back at me.

February 13

Scientists have just this minute published their analysis of the
human genome. We were formally estimated to have a hundred
thousand genes, are found to have only thirty thousand—a
third more than the ringworm. "The human genome is minis-
cule in size—two copies are packed into the nucleus of each
ordinary human cell, itself too small to be seen by the naked
eye—but vast in its informational content. Composed of chem-
ical symbols designated by a four-letter alphabet of As, Ts, Cs,
and Gs, the human genome, if printed in standard type, would
cover 75,790 pages of this newspaper."[6] In addition to the
fact that the human genome is "just out of the worm league,
[it] seems to have almost too much in common with many
other kinds of animal genomes." One investigator "found only
three hundred human genes that had no counterpart in the
mouse genome."[7] It also appears that people have 99.9% of
the human genome *in common*. A revolution as radical as the
Copernican. We are no more central to the inhabitants of
the earth than the earth is integral to the celestial bodies of
the universe.

An unmanned spacecraft landed on the asteroid Eros yester-
day afternoon. Eros is twenty-one miles by eight miles (almost
twice the size of Manhattan) and is shaped like a baking potato
with lots of bumps on it.

The space station orbiting our earth looks to be alive,
some kind of fascinating insect. Men and women in space
suits attach to it by cords, attend to and extend it. The human
genome intends to leave this planet.

In the meanwhile, we have to find a foothold in an avalanche
of information telling us how small we are, how insignificant
we are, how we really do not signify at all because there is no

reality for us to signify in. The artists who are currently depicting physical bodies and their products in all sorts of ways are actually humanists: no matter what the context, these works of art say, we remain human.

February 17

Just before the opening of the exhibition in New York, I was told that a collector in Los Angeles had bought *Breeze* (1978). *Breeze* lives as if within a lovely glade, a time in my life so full of hope that the air there hums.

My life is so distilled in every work I make that when it is bought that part of my life goes with it. This used to make me suffer. I still feel a pang, but I can afford to let it go ever more easily: I have noticed that what I have truly had I do not lose.

February 17

I feel like writing more. I returned home from the opening of my exhibition in New York happy, with a kaleidoscope of images and thoughts. But my body just wants to lie prone, to be let alone. My body leads me more nowadays. I am not relaxed. The tempo is just slower.

Nan Graham came to the opening. Nan accepted the manuscript of *Daybook* when she was a young editor at Pantheon; then *Turn* at Viking; and *Prospect* at Scribner, where she is now editor-in-chief. Her presence, and the delicate roses she sent me with the mutual friend who originally brought us together over twenty years ago, felt to me perhaps an omen: this writing I am doing might actually become another book.

If so, good. If not, good. I am happy with the companionship of my stiff-backed notebook and my smooth-flowing pen.

February 18

My very first exhibition as an artist standing alone was in February 1963, thirty-eight years ago almost to this day, with André Emmerich. His gallery at that time was a rectangular slot on East Sixty-Third Street, a tight squeeze for my looming dark rectangular structures. We were young then, in our late thirties (André) and early forties (I). We grew together during the thirty-two years in which he was my dealer. So we stood together at the opening, pentimenti, and tacitly measured change while we affectionately caught up on the present.

Another pentimento: Tobias Schneebaum. We have been friends since 1950, when we met on the shore of Lake Chapala in the village of Ajijic, Mexico. A film of his extraordinary life as an artist walking—literally—around the world is currently winning prizes. Parkinson's disease has clawed Toby down. His memory is being overtaken by patches of forgetfulness like those no-color clouds that invade the scene in Japanese paintings. When I say, "Do you remember . . . ?", he says No. The past we have held in common for fifty years I have now to hold alone. His memory of James in particular, of James and me as a couple, has been dear to me. Gone now.

Toby is brave. He looks out of his pale face as plainly as he always has. His face says, "What did you expect?" We used to laugh that he expected the worst, I, the best.

February 19

Acquiescence. I tend toward the quiet. Time brings submission to creaturehood, perhaps? To what animals feel as they go about their accustomed ways? The black squirrels who live around us will soon descend from their twig nests high in the bare trees and once again make tracks over fences and up and down branches while I dig in my garden, all of us equally absorbed in the immediate.

Sam Kusack and Charles Finch, two of my grandsons who came to the opening in New York, are just as absorbed in the immediate, but their immediate is not creaturely. Each is on an ambitious path that watches his natural bent (it seems to me) but is distinct from it. Their aims are clear, private, and personal. They drive themselves *against* impulses that would lead them to subside into a general pattern. In contrast to the squirrels, who behave like squirrels everywhere.

Or to me. But I am like my grandsons too. I fight. I give way but do not give in.

When I give way to creaturehood, I become less *myself* and see that when in time I have to submit to what Gabriel García Márquez calls "the authority of death" I will die as any old woman.

The exhibition remains in my mind, but every day it recedes. The four sculptures on which I am now working absorb me. And I have ordered six more armatures for sculptures to be fabricated.

February 20

A snowstorm was predicted yesterday. I reached the grocery store early and continued on to the library, intent on getting in

a supply of books too. I emerged into an instant blizzard, ice already underfoot. A five-minute drive lengthened to almost an hour as route after route was blocked by drivers who had panicked, had simply stopped on hills or shoved on the brakes and skidded sideways. Driving in third gear, I took to the flattest land and made it near enough to home to walk there in careful baby steps in the deepening, blowing snow.

I am reminded of a woman I knew in Japan. Frances had lived for years in Tokyo before the war. When she returned immediately after the surrender, she found the city virtually obliterated by bombs. Forced to flee, Japanese families had, before they left, placed under conspicuous stones pieces of paper with information about their planned new location. The only way Frances could navigate was by remembering the contours of the land under the city. By following these ups and downs, on foot, she found her friends.

February 21

Three sculptures, *Gloucester* (1963), *Valley Forge* (1963), and *Single* (1975), were taken out of storage and sent to my New York gallery last week. A collector will look at them tomorrow. When they were unwrapped yesterday, the brush strokes and wood grain were visible in *Gloucester* and *Valley Forge.*

My sculptures are in a way analogous to time. The intrinsic nature of what they are made of is emerging: chemical changes in the paint on *Gloucester* and a characteristic of the poplar wood of which *Valley Forge* was constructed. When I made the decision to make my sculptures out of wood, I remember calculating that eventually their individuality would be embodied by the determination of their material. Now I have lived long enough to see this determination beginning to happen. Only

beginning: sculptures hold their own. And the fact that they record time is intrinsic to their essence.

Mine also. We—they and I—are individually on our way to disintegration. I am different in that I have the privilege of consciousness of myself relinquishing my own individuality.

February 28

The last day of my favorite month. A clump of snowdrops is blooming around the corner. My forsythia is budding. It leans over the short stalks of the jonquils pushing up under it and the round, rough-leaved primrose plants that a friend gave me for my birthday some fifteen years ago.

President Bush presented his budget to a joint session of Congress last night. He may be the most stubborn of the presidents I have watched pass through Washington: he *intends* to plough the straight row he laid out in his campaign—no matter what. But I do not agree that we, the "American people" so often and so unctuously invoked, *want* to isolate ourselves behind the bristles of a missile defense system.

We would prefer to foster our mutuality with the rest of the world. We do not want inordinate tax cuts. We would prefer to share our resources with the less fortunate people, both native and foreign, we see nightly on the news who are impoverished, sick, and starving. We would prefer to change our habits if we have to do so to protect the blue-and-green-and-white planet that we have also seen from space with our own eyes to be singularly life-giving within the reaches of space.

I honestly feel that President Bush is trying to lead the country toward civil selfishness. Generosity is our true strength as a nation. We had to be neighborly to survive in the wilderness we

found in this land, to which we all come to from far away. For this reason we perhaps could understand that strength springs from unity. Neighborly unity, national unity, planetary unity.

The world is a school I think; we learn here. Nonetheless, I feel sad that we live here in relentless disharmony. At least that's the way I myself see matters.

The cant is that older people get less and less interested in a world they will soon leave. Not so for me. "Me" is becoming less and less me, more and more generic. My remaining time here is running out like a string in my hand.

March 2

This morning I visited a new friend who is dying with presence of mind. She lies among her blue-and-white pillows at rest except for now-intractable trembling. Her dog stretches on her bed, eloquently close to her legs. Her disease has, so far, spared her voice: "We are born out of reality and we die into reality."

This afternoon an old friend came for tea. Martin Puryear is a sculptor. We met in 1975. I first saw him at a little distance up a hill and immediately felt that he was marked for success by the sure way his feet met the ground. David Smith had that balance: he walked like a ship sailing confidently in a compatible wind.

People who are not artists tend to think that artists talk about art. More often art is taken for granted. Martin and I spoke of how we live, not what we do.

March 4

Édouard Manet was born in 1832. In 1879 he contracted syphilis, and for the remaining four years of his life was an invalid. Confined, he made small still life paintings, currently collected in an exhibition at the Walters Art Museum in Baltimore. I saw them there yesterday.

The hand is not prerequisite to art—Marcel Duchamp et al.—but when the artist's vital force springs into and out of the artist's hand, the effect is utterly intimate. In Manet's case, gallant too.

James Joyce noticed that certain things in the world matched him. Manet is master of a precise territory between recognition and revelation. His bunch of plump asparagus—purples, greens, whites, blues, grays—appended by a tiny painting of a single stalk (hanging empathetically off a table), changes asparagus. Peonies, roses, lilacs, his violets—all his flowers—seem to have voices. They are so eloquent and so perfect that they redefine perfection.

March 11

To think something seems to magnetize something. Perhaps that is how we make our lives: we summon them. Like Prospero calling Ariel. Our ordinary lives are imaginary. Our human situation is the opposite of what I thought it to be: *this* life, imaginary, tentative. Life, out of which we are born, into which we die, has substantiality. We entertain private narratives.

Trying to pour my life from one vessel (this place, planet) through a very narrow neck into another unknown vessel: like an element, limitless, concentrated, intense, fascinating failure.

March 13

Late yesterday afternoon I walked to the Washington Home
to visit with Cord and his wife, Starke. The Washington Home
has been happily redesignated; "The Home for Incurables"
used to be carved into the stone arch over its entrance, placed
just right to meet the eyes of patients entering on a stretch-
er. Now, welcoming wide doors, glass walls, windows, and
landscaped courtyards (I saw all early pink peach blossoms).
Patients enter elsewhere, and when visible are decent ver-
sions of their former selves.

Dear Cord, friend of almost fifty years, was decent but
asleep. Aslant in his wheelchair, and so emaciated that his arms,
emerging from the short sleeves of one of those woven-cotton
shirts, were maps of the blood remaining in his body. Starke and
I talked a while in low voices of practical matters: of his archive
in the Library of Congress; of the diaries Cord kept, every day,
year after year; of a large book of family photographs; of a small
box containing Cord's baby curls, along with more of his twin
brother Quentin's (also a marine lieutenant on Iwo Jima). We
stuck to details, and from the details emerged the awkward fact
a life leaves the problem of detritus.

Cord's hair is silver and thick. I put my cheek against the top
of his unconscious head, on the last remaining vigorous thing
about him, and stomped home remembering, remembering.

* * *

Cord died at 2:00 this afternoon.

March 16

Eighty years ago at this moment, 3:15 a.m., my mother must
have reached the pushing stage of labor. She was thirty-two,
slender-boned, delicate in mien and way, but healthy. She
always emphasized that having a baby was "of course" pain-
ful but "at the end you have *your baby!*" Father, forty-two,
was probably far more anxious: he bit his nails all his life, his
fingers ended in soft round pads. The very ordinary drama
of my birth took place in Baltimore at the Maryland Hospital
for Women—right around the corner, I was to discover years
later, from the Maryland Institute College of Art where I
taught while in my seventies.

After I was born Mother and Father returned by ferry across
the Chesapeake Bay, home to Easton, a very small town (with-
out a hospital) on the Eastern Shore of Maryland. The first
journey I ever took was on water.

Alexandra and Jerry are asleep. Last night they took me out
to dinner at the Lebanese Taverna "to start my birthday off
right." A table on which small, round, patterned pottery dishes
of eggplant and chickpeas and beans and tiny buttery pastries
full of spinach, embedded with pine nuts or grains or what-
ever, all accompanied by what looked like cream but was pure
white smooth glistening cheese, which reminded me of the
pure white smooth glistening paint on the Wayne Thiebaud
pictures we had seen that morning. Exotic food from a sliver
of a country that means to me the Roman poet Horace: at
dinner he drank "wine cooled by the snows of Lebanon."

I look up from my notebook. A light wind is blowing through
my translucent white-embroidered white curtains. Everything
I see in the soft lamplight is familiar: my mother's bow-front
bureau with an oval mirror surrounded by two violin-shaped

supports; her desk, the one her father made for her, still with her own chair in its kneehole; a bookcase of family photographs: sisters, children, baby grandchildren, and four grownup grandchildren, friends: formal at weddings, sprawled on benches, laughing and curious, determined (Charlie at three striding up a country road in Vermont), playful (Sammy and Alastair on their little bicycles in Central Park). One of my twin sisters and myself on a blanket on the lawn at Avonlea, the twins so young that they cannot sit up by themselves so I am trying to hold us three up together, all of us in charming white lawn dresses with ribbons laced through little ruffs at our necks. Every thing I see and every image caught and fixed as it swept past was and is real, was and is my life. Suddenly I see it in whole proportions: a done thing. The view is wide.

Spring

March 24

I find I like being eighty. I like the number 80: the symbol of eternity turned sideways next to the symbol of never-beginning, never-ending wholeness.

Eight decades under my feet lifting me up so I see farther backwards and farther forwards.

I feel patient. Looking out from here I may begin to think, "Oh, *that's* how *that* happened."

March 25

Two Washington acquaintances died this week. I knew neither well but both for many years, so I saw their lives in longitudinal section, narratives running more or less parallel to mine. I miss their tacit company. One an artist, Jacob Kainen; the other a journalist, Rowland Evans. Both led long, interesting, and enterprising lives. Both were "known." But once dead, they could have been bubbles: quite literally air departed from them— their breath became air, and both left behind them their effort. Their effort counted. While they owned their own breath, they counted. Now their breath is air—unowned, uncounted.

March 27

Mary was born on a clear morning in San Francisco forty-three years ago today. She was destined to bring forth five children. Born on the East Coast in four states strung out along the Atlantic Ocean, she delivered each in determination and courage, without the artifice of medical interference. Each lay against her skin

from the moment of birth, held close. Her own birth was cruel: the anesthesiologist put the spinal injection into my back in the wrong place so I could feel my innards displaced and the baby removed; my first sight of her was from a great distance, against the light, held up by an indifferent young man who didn't even take the trouble to wrap her up in the cold air of the operating room—her arms and legs hung out helter-skelter. The surgeon said "Put her under" and I was gone.

Was Mary's fierce maternal instinct born when she was born?

March 28

I lifted a basket of laundry about ten days ago and even as I did so—had done so—realized that it was heavier than I had thought. I felt something go wrong in my back right next to my spinal column, low down on the right-hand side, and instantly decided to act as if nothing had happened. Sometimes that works, but not this time.

March 30

Cord was buried in Arlington National Cemetery yesterday, and now lies gathered into the company of those who served this country in war. We mourners wound in a long procession of cars timed to the slow march of the honor guard that preceded the caisson bearing his body, drawn by six black horses whose coats shone in the icy rain. A brass band played martial music. The sound echoed and reverberated over the hills and valleys and meadows of white crosses: "So many. I had not thought death had undone so many."

March 31

From the oration of Pericles over the Athenian dead in the Peloponnesian Wars, delivered in Athens in 430 BC:

> For the whole Earth is the Sepulcher of famous men; and their story is not graven only on stone over their native earth, but lives on far away, without visible symbol, woven into the stuff of other men's lives.[8]

Not only "famous men"—all of us. And however thoughtfully we live we do not know what strands we leave behind, woven into other lives.

April 3

My ancestor, James Collier, was born in Cohasset, Massachusetts, in August 1813 in the house built by his great-grandfather, Thomas Lincoln. At nine he said to his parents, "Let me go fishing, or I'll run away," and his father let him ship out on one of the vessels he owned. At eighteen he was made captain of the schooner *Profit:* he left Boston carrying a general cargo for Norfolk and Richmond, returned carrying coal by way of Weymouth. Henceforth, until he was seventy-three, he crisscrossed all the oceans of the earth, "commanded more ships and sailed more long voyages than any seafaring man who ever went out from Cohasset. [. . .] Besides the ports touched at in the United States in his early coasting trips, a partial record of ports he visited is as follows: Coquimbo, Maracaibo, Queenstown, Malaga, Antwerp, Chincha, Valparaiso, Porto Rico, Singapore, Cardiff, Kingston, Santiago, Yucatan, Bordeaux, Buenos Ayres, Monte

Video, Mauritius, once each; Rio Janeiro, twice; Melbourne and Bombay, three times; Callao four times; London and Calcutta, six times; New Orleans, seven; Liverpool, eight; and San Francisco, ten times."[9]

He sailed prudently. And he had that subtle combination of authority and geniality that made him able to run "a happy ship."

April 5

Two sculptures, sixty by five and a half by four inches, are almost finished. Two lines of color and they will be done, probably by this time next week. I now sometimes have to sit down between coats of paint. I have the ice cream parlor chair I took with me from the 1928 Calvert Street studio (before I built my own) with the pillow I made years and years ago with dark-blue-and-white-patterned Japanese cotton *yukata* material. I sit and watch the light move over the sculptures, the stored paintings and the uneven but lined-up rows of jars (peanut butter, molasses, jam) of leftover paint. I feel I am where I should be on the face of the earth.

April 7

The Japanese word for white-flowering plum tree is *ume*. White *ume* was the first sign of spring, sad-looking twigs would over-night come into delight. My neighbor's plum tree, visible from my bed, is as suddenly in bloom; not as delicate as Japanese *ume* though—rather coarse, thick flowers.

This tree was a sapling when I bought this house in 1969. The tree I used to watch from my bed was a full-grown sugar

maple and I dearly loved it, cherished its seasons until one dark afternoon a great wind uprooted it and flung it into the street.

Most of the buildings in Wakamatsu-cho, where we lived in Shinjuku, Tokyo, were low, two-story wooden structures. Only occasionally separated by tiny courtyards, they lived in community with the twisting lanes left behind as old villages spread into the continuity of the city. When snow fell, white revealed the horizontal roofs, the vertical struts, the infinitely varied amber and gray woods—drab but endearing buildings.

* * *

The *distinctness* of consciousness.
A point at the apex of a triangle.

Do not experience it diagrammatically; no form whatsoever—
 that's why it's daunting. No formulation is possible.
But distinct it is.
A point of caress making definition in accordance with a
 singular physical apparatus.
Very tiny singular differences.
Point because virtually nonexistent.

* * *

If a book, the title is *YIELD*.

* * *

My cousin Alice on men's attitude toward abortion—refusal to pass laws allowing procedure: "I put it there and because I put it there it's going to stay there."

We—women born in the 1920s—are silent. We were *stricken* silent by having to send men to war without weakening their superstition: "If I don't weaken him, he will be stronger to defend himself, and may survive battle." We were *kept* silent because the men who returned were by then accustomed to a world in which only men counted—force, action, endurance. And in which they *too* had had to be silent while being liable to being killed or to killing. Self-brutalization.

April 8

Last night Sam (he is here for a few days studying) and I watched Stanley Kubrick's *Full Metal Jacket*. When it ended, we did ordinary things for a while to let its force dissipate, but a bad dream woke me up later.

One virtue of art is that it challenges "reality" and succeeds in changing it. Kubrick has forced me to know that I know nothing except facts about war, *cannot* imagine it because imagination is *not* actual, and can be an impertinent effrontery.

April 12

My mother's sister, who visited "Clover Fields" in Keswick, Virginia, when she was a young woman, met there and married an irresistible Virginian, died forty years ago today. A photograph taken just after they were engaged transfixes forever Aunt Nancy and Uncle Jim as a charmed match—both blue-eyed, fair-skinned, light-haired. They radiate a lovely confidence.

When both my parents became ill in 1934, Aunt Nancy and Uncle Jim absorbed my younger twin sisters and me into

their family of four children. We stayed with them on their hill overlooking the distant Blue Ridge Mountains outside Charlottesville over a summer and a winter, and never returned to live in Easton, Maryland. My parents sold their beautiful house there and moved us all to Asheville, North Carolina, in the fall of 1935. They exiled us all—my sisters and me and themselves. Not one of us was ever to be as "at home" again. A complex decision. It took courage. I respect that. I suspect too that one of the elements may have been the urge to change on more levels than geographical. But it was a bad decision. They lost their *place* in the world. They were not faithful to what it had taken them fifteen years to build. They did not have fifteen more years—my mother died in 1941. They failed to understand how tenacity can underwrite change. If everything changes at once, the changes are too drastic, unwieldy, and sometimes impossible to integrate.

But on my way to exile, my sisters and I learned a great deal on Aunt Nancy and Uncle Jim's little mountain in Virginia. Louise learned to ride horses. Harriet learned to milk cows. I learned how to be cheerful in daily life—Aunt Nancy and Uncle Jim were cheerful, vigorous, hopeful people—and Aunt Nancy taught me how to use my mind and hands to make things. She was always making things: embroidered crewel chair seats, clothes (she made her four-year-old daughter Jane enchanting blue jeans and shirts), pretty flowered cotton bags with circular cardboard bottoms sewn in to make them sturdy, delectable tiny cupcakes dipped right out of the oven into hot sugared orange and lemon juice. Most of all, she made happiness. Every afternoon we had tea, by the fire in winter, on the lawn in summer, and to see Aunt Nancy with the great round tray holding teapot and lots of different kinds of cups and saucers (she liked variety) was to know that good conversation was afoot. She liked talking about any subject

that came up, and she was the first person I know who engaged her own life as a source of conversation. What it was like to be a child in her father's house in Cohasset, Massachusetts, overlooking the ocean; what it was like to fall in love, to get married, to stay married, to deliver babies into the world, to bring them up, to see them married, to have grandchildren . . . to grow old.

But she never got to be very old. I was called to the telephone one night when James and I were giving a dinner party. Jane, her daughter, said that Aunt Nancy had had a heart attack, was in the hospital, was not expected to live. I left for Charlottesville at dawn the next morning and was able to hold her hand, her kind and capable hand, before she died.

Only sixty-eight. That seems to me so young.

I sometimes yearn to return, to stay once again in the little guest cottage with the trumpet vine bursting over the chimney, to take with me my children, and my grandchildren. Daydreaming, I bump along the dirt road that curves over the brook and up the hill toward the gray-and-white house under the tall oak trees between which Aunt Nancy steps quickly forward, to welcome us. The tea tray is all set out on the lawn . . .

April 13

At André Emmerich's request, I spent some hours yesterday afternoon with a graduate student from Hunter College. One of the questions she asked me was what would I have done had I earned more money. She didn't mean to make me sad, but she did: images of the sculptures I have not been able to make rose up in my inner eye, springing up around and over me like a forest of balloons inflating. I was surprised by how fresh they looked: urgent, untried, somehow innocent.

April 14

Two coincidences: I watched an independent film on television.
A young man appeared in an interval: "I'm Noah Emmerich…"
André Emmerich's son. In another interval I saw out of the
corner of my eye (was reading with the TV muted so as not to
have to listen to the ads for future films) some native people
decorated with feathers who looked like Toby Schneebaum's
tribe. Unmuted, and heard Toby's voice. There he was too, first
as a young man being interviewed (yes, he had eaten human
flesh) and then as he is now crouched at the end of a log canoe
being rowed down the river he once kept on his right. His life
has turned him into a shaman.

Third event: I was going upstairs, pausing over each uncom-
fortable step. Stepped on one, I was surprised to find myself look-
ing at myself as if not myself, walking upstairs in my house alone.

Phenomena are unreal—I see more and more clearly, hence
representation cannot be other than unreal—unless illumi-
nated by art, which is not based on the phenomenal world but
rises accordingly.

Art refers to the laws behind appearance.

Islam: forbids representation—for this reason?

Glad my work was never representational.

April 16

I watched Bergman's *Wild Strawberries* yesterday afternoon.
Ever since I saw it in my thirties I have been haunted by its
atmosphere: literal sky and air, gray clouds and storm and
sun—and emotion. The terror of dreams, terror of self-
revelation. The terror of guilt, the guilt that is intrinsic to

being human. Because being human is so painful that we rescue ourselves by way of imagination. We shape our lives into narratives so self-protective that we fail to see how cruelly we are all hurting one another. In my thirties I questioned what felt to me—in my own self-protective narrative—like Bergman's neurotic pessimism. But the beauty of his film lingered in the back of my mind until living long enough could deliver me into understanding. In a final scene the protagonist, an intelligent, distinguished, successful old man looking back on his long life, remembers seeing his parents. He is a little boy, secure in a tribe of ten children. It is high, hot summer. He stands on a low riverbank. Across an inlet, at bird's-eye level, he sees his father fishing. His mother sits on a hillock near her husband sewing something white. Their clothes are white. They are fixed in flat white afternoon light. Still. They sense his presence. They lift their heads. They smile. They wave.

The movie ends.

Memories remain.

A life is, after all, sensory. Experienced by the senses, recorded in the senses. Retained by the senses, but examined by selves independent of the senses.

April 19

Gabriel García Márquez writes, "Always remember, the most important thing in a good marriage is not happiness, but stability."[10]

But *I* feel too sad this morning to write about marriage. I woke up chilled and can't warm up. And when I close my eyes to compose myself I slip away, backwards or forwards, I can't tell which, from my life as if it tapered out at both ends. And

distorted—I might never have been born at all. Yet I miss my very own life, miss my husband and my babies, waking up into the clamor of a family and soothing my children at twilight, singing them to sleep and then being with my husband in the quiet night.

April 20

A while ago Sam remarked that my house was "getting too shabby." I looked around, saw that my standards had piteously sagged, and took measures. Smith, Thomas & Smith built my studio in 1971. They have taken care of me ever since, and now into the third generation—the grandsons of one of the original Mr. Smiths built the cabinets in the room overlooking the garden where I have my desk, telephone, fax, files, and now email. Today they will finish painting all the radiators, the windowsills, the kitchen ceiling, and "touch-ups." The bathroom is now palest shell pink.

Only one of the men who have adroitly done all this painting speaks any English, and he not much. Sonny, an old friend at Smith, Thomas, mixes the paint and pops in and out to see how things are going, but for the past week I have been one of a silent company: I paint in the studio, they paint in the house. We smile. They do not speak to one another much either. I think each was born in a different country. They are here now, make good livings—one of the reasons I pay the higher fees of Smith, Thomas is that the company takes good care of its employees. I am glad that I live in a welcoming country.

April 23

Two young Italian artists who use the internet as an art medium have initiated a project they call *Life Sharing:* virtually total access to their computer.[11] These records can be downloaded in a variety of languages, and because they are so comprehensive the artists claim that they effectively constitute their lives, the content of their art. Also that the way in which the computer accepts and uses data by inference is comparable to the way a brush accepts and moves paint—is a valid extension of traditional artistic devices. Authorities at the Walker Art Center in Minneapolis agree: they commissioned *Life Sharing*.

I do not disagree—I think of Edwin Abbott's *Flatland:* the extension of a geography that is perfectly logical—but I do find I miss Robert Motherwell's "something in you that rises simply, beautifully, and unpredictably as the flight of a bird."[12]

A computer can only record facts, and even unusual facts sooner or later arrange themselves into a narrative, and human narratives tend to flatten out into a common abstract curve.

I read recently about a baby afflicted with Cockayne syndrome, a rare genetic dysfunction characterized by severely impaired sensory neurons, poor growth, mental retardation, and death within a few years of birth.

The baby I read about was four pounds at birth. He had cataracts in both his extraordinarily tiny eyes and almost no hearing in his malformed ears. His joints were so contracted that he could extend neither arms nor feet. His skin was so thin that he got sunburned even on a cloudy day when protected by clothes and sunblock. He was prone to dental cavities.

His parents were devoted and indefatigable. An ophthalmologist repaired his cataracts and fitted him with contact lenses. A tracheotomy enabled him to breathe and a feeding tube to

get nourishment. Even so, he slowly but surely lost vision, hearing, even the senses of touch and smell. He died just before his second birthday. At his memorial service, his father spoke of the life his son had lived embedded deep down inside his deteriorating body. He spoke of a swing he and his wife had devised, lined with a soft, comfortable cloth and hung from a tree. They would put him into it—at night of course—and swing him gently back and forth under the stars. His breath came easier, his face relaxed. He seemed to enter an inner realm of calm serenity, even—they felt—of joy.

In that realm, not subject to record, familiar to us all, there are no facts. Out of it art occasionally springs.

NEW YORK CITY
April 26

I am on the sixth floor of the Cosmopolitan Club in Manhattan, in one of two small rooms sharing a bath—Alexandra arrives later today to take the second room. This room faces east and north. I wake up facing north: a neat Hopper roofline distinct against a pale-lemony sky. I listened for a while to the call of New York doves, who sound exactly like Tucson doves. I slept deeply, my head due east, feet due west. At home I line up head north, feet south—maybe a change of alignment evokes a good sleep.

But more likely I was just tuckered out.

Sam met my train. We had lunch here at the club and then went downtown to Cooper Union to see my grandson Sam's senior exhibition.

His methodology is as mechanical as that of the computer but more familiar to me, and beautiful in itself: finely tooled

wheels mesh one into one another to make an element move: to rotate a large gray granite rock and incise on it a line that reveals the stone's texture and will in years and years cut the stone in two; to tip delicate, pure, pulverized sand into a bright brass half-hour glass; to move a lever on which a steel pipe is balanced in such a way that it will topple someday. In one work the gears themselves, moving very, very slowly, can be seen in dim light way down at the bottom of what looks like a telescope, reversed, as if they moved the bodies in an upside-down firmament. In another, sand that his mother recently brought home from India is spread thinly on a large, flat, shining metal tray, slightly tipped; transparent tubes then emit gentle spurts of water onto the tray so the sand separates into rivulets that dry slowly, only to be wetted again in new patterns. The mesmerizing "landscape" looks like the earth from space.

Thinking the day over, after dinner with Sam and his wife Flo but before plummeting into sleep, I felt simple, a wheel geared to, moving and being moved by other wheels.

April 26

Alexandra and I walked up Madison Avenue and into the Frick Collection. We sat in the courtyard, as we both have done since our twenties; the fountain is the same but the plants looked poorly. I showed her the little auditorium where I once heard Myra Hess play the piano so nobly, and spoke about how she gave regular concerts all through the London Blitz, every day as I remember, and they were free.

Alexandra's favorite painting is Titian's *Portrait of a Man in a Red Cap* (c. 1510): his distinguished dignity, inflected by the

sensuousness of his fur collar, fur enlivened by almost-breathable fresh air. My favorite in my twenties is right next to it: Bellini's *St. Francis in the Desert* (c. 1476–78). I used to stand transfixed by the flood of light, the sheer power of gold and blue, and by the concept of silent, solitary, diligent study (the cell on the right of the painting) interrupted by revelations. Somehow that light has faded for me; or have I lost faith in the idea that dedication summons results? I now turn back and back to Rembrandt's *Self-Portrait* (1658): self not as protagonist, but as human experience fully present in a body scarcely separable from what is around it, permeable and permeated.

<p style="text-align:center">* * *</p>

The party to celebrate the publication of James Meyer's *Minimalism: Art and Polemics in the Sixties* was at the Paula Cooper Gallery. We approached it from the east, facing into a de Chirico cityscape backlit from the west, a wide empty street lined with flat, mute, blank walls.

While hunting my own "beast in view," I used sometimes to entertain the idea that an art historian would come along and explain to me what had been happening while I was not paying attention. James Meyer did. His book sorts, clarifies, isolates, and analyzes the forces that I used to feel as storms that darkened the air even though I kept a distance. He deals primarily with six "Minimal" artists—Carl Andre, Dan Flavin, Donald Judd, Sol LeWitt, Robert Morris—and it became apparent to him that I had been there too, had been a fact, if not a factor. Two of these artists, Dan Flavin and Donald Judd, have died. Carl Andre came to the party. I had forgotten the flavor of the company of artists. In one of the coincidences that no longer seem to me as much coincidental as focal, Carl grew up in Quincy, Massachusetts, just south of Cohasset; both our

families had to do with the sea, his as ship builders—the very best of all trades. Imagine the delight in sending forth a well-made ship to sail around and around the planet!

Home to DC.

Decrease in physical stamina—cancelled Maine and Massachusetts.

May 1

"Eddy" is what Misha, who worked with me in the studio for some years, calls what I have been in and am coming out of: an agitated, small, round backwater of the major stream of my days. When caught in an eddy I go round and round and feel like Eeyore when he slipped into the river and just revolved there with his four feet stuck up into the air.

If a lot happens to me all at once, I can't seem to take it in as I go. I just *stop* making an effort and let myself get borne off with what I hope will be a quiet pool of contemplation, but is instead one of tightly whorled obsession. Obsession is generally a good and trusted friend. My work is propelled by the obsession to make what is real to me real to other people. Healthy obsession: a goal that energizes and magnetizes a life.

But my tiny backwater is brackish. I have been going over and over and around and around my visit to New York, its refraction of forays there in the 1960s. Forty years: I have trouble believing it was forty years ago. I am reluctant to believe it,

and seem silly to myself, unworthy of my eighty years. Over and over and round and round—memories. Memory could become the substance of a person's life.

As always, I retreat into my core and there I find that I am very, very tired and that my body hurts me all the time. I am going to the doctor tomorrow morning.

May 3

The doctor said, "I count on you going on." And on I went.

Had my car washed. Wrote a demanding letter. Moved toward summer in my house: arrangements for my new screens, clothes put away and taken out. Best of all: a coat of paint on my new sculpture. Its name is, I think, *Twining Court*. A memory but an invigorating one. Twining Court was the name of a mews (now obliterated by rather tacky townhouses) between O and P Streets. Just east of the P Street Bridge over Rock Creek Park. My studio in the 1960s was a carriage house in this mews. A dilapidated brick building with two stories: space for the carriage and horses below (not when I worked there), and quarters for the coachman and his family above. No water. No heat. Day after day, week after week, month after month, from 1962 to 1964, when we moved to Japan, I got acquainted with what my work was going to be for the rest of my life. I made discoveries. I was intoxicated.

May 5

Bob Kerrey, until last January the senator from Nebraska, now the president of the New School in Manhattan, was a team

leader in the SEALS (SEAL = Sea + Air + Land) in the Vietnam War. Last week a story was published about his behavior then.

Kerrey was twenty-five and "had been in Vietnam for scarcely a month when, on the night of February 25, 1969, during a raid on a hamlet called Thanh Phong, he and his six-man team shot and killed at least thirteen defenseless women and children. [...] Kerrey says that he and his men killed the people from a distance and only later discovered that they were women and children, and unarmed. However, one of his comrades [...] insists that the civilians were rounded up and killed at close range, and that it was Kerrey who gave the order to kill them."[13]

Kerrey was awarded a Bronze Star for his leadership at Thanh Phong, and the Medal of Honor for a later enemy engagement during which he lost the lower part of his right leg.

Bob Kerrey: "I thought dying for your country was the worst thing that could happen to you, and I don't think it is. I think killing for your country can be a lot worse. Because that's the memory that haunts. [...] Around the farm, there is an activity no one likes to do. Yet it is sometimes necessary. When a cat gives births to kittens that aren't needed, the kittens must be destroyed. And there is a moment when you're holding the kitten under the water when you know that if you bring that kitten back above the water it will live, and if you don't bring it back above in that instant the kitten will be dead. This, for me, is a perfect metaphor for those dreadful moments in war when you do not quite do what you previously thought you would do."

And when he has done what he had not previously thought he would do, a person has gone "where no one comes back whole."[14]

The "memory that haunts" could not be caught by a computer: the Italian artists who rely on it mistake accuracy for truth (miss the very point of life).

We will never know the facts of what happened on that night thirty-two years ago. What we can know is their effect on the men who experienced their truth. At a wider remove, this truth was what haunted me during World War II when I saw, as patients, men just returned from the Pacific battles with the diagnosis of "battle fatigue." This syndrome was commonly thought to embody the fear of being maimed or killed, but, alone and beyond was the terrible truth that these men had been trained to kill, to be killed, and then had been sent forth. They had been shot at, had shot back; they had killed, and some of them could not bear having killed. I slowly came to know that to return force with force was in psychological truth fatal to both killer as well as killed. This influenced my pacifism.

May 9

Yesterday when I woke up I felt ninety.

The day before I felt upward of one hundred.

This morning I feel about sixty-five.

As I think to lift off out of my body, to slide out and slip away free, its grip is tightening. My muscles clutch me. Could it be that a body becomes possessive? That, like Proteus in the arms of Hercules, it brings changes to hold onto its shape? I feel it that way, amoebic: muscles pinch here and let go there. I become somewhat incoherent physically: I stumble, lurch, lean. I sleep quickly, unexpectedly, wake up with the light on, my book dropped on my chest, with my hands still holding the pages open in place—and only an hour has passed. The whole night is ahead of me and I am no longer sleepy.

I see in my doctors' eyes a look that I have not seen so naked before: assessment. Behind is kindness but assessment comes

first, as if in me they were observing an example. They see where I am going and are looking to see how I am going to get there, which of the very familiar paths I will take.

A balance between my mind and my body may be tipping in favor of my body. When doing errands, I abandoned one of my major purposes because I would have had to walk a few blocks to accomplish it. I will instead "make do."

May 10

Now Morris Graves has died. Ninety. In California, on his own acres, under his own virgin redwoods, his own Japanese-like buildings, alongside the lake he himself made. This place will become an artist's retreat under the aegis of the Morris Graves Foundation. Donald Judd too: he left a whole town, Marfa, in Texas, a memorial to his life, his work, and his polemic in art. David Smith left Bolton Landing behind him: his house, his studio, the fields his sculptures used to stalk. I remember when Morris Graves became visible in the form of delicate, light paintings with not much on them. Akin to Paul Klee's but without the self-conscious playfulness that makes Klee's work a little silly, even "twee." Graves stood aloof. Skinny-legged birds simply existed somewhere within an atmosphere in his *Inner Eye* series.

I so liked the way Graves let things be. I feel his loss. Graves's life was a plumb line. He too was a pacifist, and paid for his principles, as I, a woman, have not: he was imprisoned for eleven months. He leaves behind him a salty, oceanic scent.

May 11

Old age is a radical situation. Time will eventually arrive at my door.

The other day I had for the first time a *lot* of trouble getting the groceries up the steps and into the house, had to do it in a relay of brown bags deposited and retrieved. The wicker laundry basket no longer goes briskly downstairs to the basement machines and back upstairs to the second floor; sometimes it just sits in-between. The ironing board is often piled with clothes and linens to be pressed. Papers tend to pile up and slither on my desk. In my garden everything is spreading into everything else. Sometimes that makes it especially lovely: pink roses have linked up with yellow roses in a great cantilever curve on the east end of the studio, above three kinds of heavenly blue iris blooming out of a thatchy flowerbed below.

I must at least consider radical change.

I do not have enough money to establish myself in an "assisted living" situation. Even if I did, I am by nature too independent, too intractable to live cheek-by-jowl with other people. I am so used to open air around me and my own ground under me. And I am prudent: I would like to conserve what money I do have for my children and grandchildren. The direction in which this country is going under President Bush's feckless aegis makes me unspeakably uneasy.

I circle my wagons. Alexandra and Jerry live too far north of my natural habitat, my native latitude and longitude, and too far away from what Julia calls my "village," the people with whom for years and years I have kept company in all weathers. Sam and Flo live in an apartment in New York. Mary and John are established in Annapolis and anchored by four children still at home: I could buy a little house near theirs, be independent yet easy to watch over.

I am daunted by all this. Ever since the sunny afternoon when I first found out that I could put one foot in front of another and step forward—from my father's hands toward the cook's voice, over the uneven brick terrace behind our house in Easton—my own independence has been a reliable foundation and a sure refuge.

May 12

When I arrived at Mary's doorstep yesterday morning to go to Grandparent's Day at Key School, where she teaches and Rosie, Julia, and Henry are students, she came out into the sunshine exclaiming, "So you are coming to Annapolis to live!"

"What makes you think that?"

"I woke up this morning and said to John, 'Mom's coming to live in Annapolis!'"

"What did John say?"

"He said, 'Good.'"

My day at school was engrossing. Henry seems to be an "alpha male"; his class (prekindergarten) is called "Henry's Group." He's so whole. When he runs, he runs. When he swings, he swings. His body is always toasty warm.

Julia's class was off on a bird walk in the woods (beyond my reach, even with a cane), so Mary passed me on to Rosie. Accompanied by two friends (how reliably friendship twines through a lifetime!) we visited her art room. I looked at their three portfolios and then sat on a grassy hill and watched two maypole dances to the tune of recorders.

Mary retrieved me, and for the rest of the day I had the pleasure of watching her teach: Carson McCullers's *Ballad of the Sad Café* and *Beowulf*. More than a pleasure, in truth: the joy of

recognizing in my daughter an inspired and inspiring teacher. And an appreciated one. Wherever we went: "Oh, Mrs. Hill!" "Oh, Mrs. Hill!"—little cries for attention. Confident cries, I noticed: she is trusted.

May 13

Alexandra and Sam concur that I might be wise to move.

Perhaps, and perhaps not. I might not be able: I would have to give up my studio.

I long ago decided that if the things I make ever cease to emerge into my minds eye, I would stop making them. It never occurred to me that they might simply continue to rise up as long as I live, bid into a body no longer able to rise to meet them.

May 14

Walter Hopps telephoned last night. He wanted me to know that he had seen my painting *Engadine I* (1990), and how he had felt. I listened and absorbed. What I tend to forget: that my work can mean something to someone else.

I am thinking that time has not yet arrived at my door. I am thinking of less radical solutions.

May 15

I paid attention to my day yesterday.

I put on coffee, checked the black paint I began two days ago on *Twining Court,* wrote in this notebook sitting up in

bed. Answered telephone calls, made telephone calls. Drove to my exercise class, stretched along with my accustomed classmates, chatted in our sunny changing room. Picked up a few groceries. Lunch. Nap. More telephone calls—one from Charlie, who is coming for a visit. Studio: checked paint. Supper. Ironing. Made Charlie's bed and put out the towel I bought for him last summer. Bath. Reading. Sleep . . .

Woke up into dawn. Turned on my back and lay in a perfectly straight line and reflected on the perfectly straight recognition that yesterday had been the yield of years and years of purposeful activity. Remembered my parents who abandoned the life it had taken fifteen years to create and then, sadly, had not enough time to make another as satisfactorily rooted.

I have thought through the matter of aging. I have a sensible contingency plan.

My doctor says I am healthy. And that the "aches and pains" are natural, normal, and rhythmical. I have noticed myself that they are. A healthy woman, normal for her age, living a life that interests her.

Good.

May 17

In 1800, Napoleon was thirty-one. He had successfully completed his Egyptian campaign and had been nominated First Counsel, but he needed to consolidate his power. He looked to northern Italy, at that time occupied by Austrian troops under General Michael von Melas. The two generals met in the Battle of Marengo on June 14. Persuaded that von Melas's major attack was only a feint, Napoleon ordered six thousand cavalrymen under the command of General Charles Desaix off the

battlefield to pursue a phantom enemy. Desaix, unconvinced of the feint, marched away so slowly that, on receipt of an anguished counterorder from Napoleon, he was able, by riding *ventre à terre,* to reach Napoleon by three o'clock, in time to reattack and to defeat the victorious Austrians.

Charles Desaix is a man after my own heart. Born de Veygoux, he sympathizes with the revolution but not with the beheading of Louis XVI—so openly that he was quietly jailed. Transmogrified into plain Charles Desaix, he became an officer of the Republic and "fought at Strasbourg, Mainz, Mannheim, and in Bavaria. He led the retreat through the Black Forest and was wounded crossing the Rhine in 1797. Then he sailed off to command a division at the battle of the Pyramids. While securing upper Egypt he clashed with the Mameluk warriors of Murad Bey, descendants of the troops that had humiliated the Mongols at Ain Jalut, and studied their tactics. On his way back to France, he was made prisoner and wrote a magnificent diary, the *Journal de voyage,* published in 1907 by Chuquet. Napoleon then recalled him to lead two divisions on the Italian front."[15]

The armies had been fighting since six in the morning. By convention, a battle lasts one day. The French had been routed. The Austrians had already begun to straggle around collecting their dead and must have begun thinking about their suppers.

"This battle is lost," Desaix is reported to have said to the despairing Napoleon. "But there's still time to win another."

Still time to win the second Battle of Marengo for Napoleon, but only a few minutes for Charles Desaix, struck down almost immediately. Shot off his horse.

Desaix simply rose above convention and circumstance. He started a battle at three o'clock, and won a victory after his own death.

"He had 'the courage of two o'clock in the morning,' the courage you must call upon when they wake you in your tent with some terrible news, and without thinking, still half asleep, you must give the right orders."[16]

The courage we all need to have, the courage that rises spontaneously out of character. The courage to imagine new solutions, to catch the moment, to transform circumstances. To forego, as Desaix did, the privilege of birth and habit, to learn from an enemy, to write it true when imprisoned. And to start a new battle at three o'clock.

May 19

Last night Charlie and I watched *Pollock,* a new movie about Jackson Pollock's life.

I could almost smell the cold-water apartments that artists lived in—called "railway flats" because the rooms were strung out in a line like trains, narrow and each leading onto the next. Scabby, leprous walls, the paint on them so thickly layered that they looked and felt like relief maps. In the second scene: the kitchen, everything jammed in, scarcely room for Pollock's sister-in-law to slam the breakfast plates on the table and skirt the clawed bathtub crowned by a circular rod hung with a dirty yellow shower curtain. Those tubs used sometimes to have hinged wooden tops that could be lowered over them so they could also be used as tables. When I left Massachusetts General Hospital at the end of World War II, I had such an apartment in Boston for one winter: sixteen dollars a month, bone-marrow cold. I lived in the kitchen and wrote on a table right next to the gas stove, and ate stews I made in an iron kettle until I had finished them and then made

another. I used to restlessly wander the streets of the North End day and night, and content: alone, working on poetry, short stories, starting a novel. Self-absorption can be exhilarating. The more meager the circumstances, the less distracting.

Jackson Pollock and Lee Krasner, both painters, lived so. Enter the world, in the persons of Peggy Guggenheim, Clement Greenberg (cruelly parodied in the movie, Clem's intelligence a fiery lance, disarmed), Betty Parsons . . . and finally, and fatally, Hans Namuth. By that time Pollock was making astonishing, radical, grand paintings.

The movie was true to what was happening when I first saw "the art world." The good conversations, the implicit, well-understood hierarchy of "quality," the mutual tolerance spiced with malice, the insider feeling—"we happy few"—the fierce competition, the mute anguish.

True too to what it is to work alone: Pollock rising up in the morning, putting on something handy, wordlessly accepting a mug of coffee from Lee Krasner, walking over the snow to his studio, making a fire in the iron stove . . . alone, silent.

And true, in the end, to the fact that when artists, natural hares, run *with* instead of *from* the hounds, the hounds will bring them down.

We children played the game of hare and hounds one summer at Lee Haven. The hare, a large boy (I was five, he must have been around eleven) carrying a bag full of little bits of white paper, took off, scattering a trail as he went and disappeared into the deep, dark woods. We waited a while and then set off after him as fast as we could run, making hound noises. We never, as I remember, caught the hare. What I remember is the pleasure of *hunting* in a pack, the fellowship of extreme exertion, sweat, and, most of all, the cries in our hot throats as we ran and ran, the exhilaration of pursuit.

There was something of that exhilaration in the art world when I first entered it in the early 1960s: critics, historians, lovers, observers, people just hanging around—all were, I felt, in pursuit. In pursuit of the Great Artist, who might appear at any time on any horizon or just in sight over any hill. Their world was hot. The talk was ardent, loud, competitive, and incessant. A kind of conceit animated the atmosphere: Paris was dead, New York was alive. New York artists led the art of the world.

All this I observed from a distance I maintained.

It took me a long while to believe that I actually am an artist. And even now, defined, I think of myself as some self I have known for as long as I can remember, whom I look out of rather than inhabit.

May 21

Some years ago a friend of mine was visiting an acquaintance at a nursing home in Virginia. On her way across the ward, her eyes accidentally crossed those of a young Vietnamese paraplegic: that instant she walked straight over to him, took his hand and said, "Will you be my friend?"

When I asked what he said to that, she said, "Nothing. He looked bewildered." She laughed. I laughed. We both relish impulse. And accept its rewards, too, in this case abiding affectionate care. Fortunately Ti was born in the United States, hence cared for under Medicaid—our tax money properly used, the able protecting the unable. His paraplegia is an unusual aftereffect of flu. Ti is unvisited by his brother; his mother will not leave Vietnam. My friend is his only friend.

May 22

My cousin Alice is coming to visit on June 2nd.

When Alice was a little girl, her mother told her that she had a "twin," a cousin also born on March 16, 1921. She had always kept this unknown counterpart vaguely in mind until two years ago when she and her husband were visiting David, the son of my mother's first cousin, an Englishman.

We spent my tenth summer in England. Cousin Alex was like my mother; she has the same delicate bones and translucent skin, but not my mother's decided character. Cousin Nip (I guess his baby name retained) was entirely decided: a beautifully put together man, plain and elegant, "one of a handful of officers who survived Gallipoli." I remember David on his tricycle, a charming little boy with a thatch of dark auburn hair. Like his father, he survived a war, and now lives in Portugal.

In the course of conversation with Alice she mentioned "our cousin's books," and it was in them that she recognized me. When she got home she telephoned me.

We took to each other instantly.

May 23

A letter recently arrived on my desk; I was astonished to recognize a Jon Whitcomb on the stamp. I have not seen his work since my teens, when his magazine illustrations were definitive in my imagining about what it would be to be grown-up and in love.

This illustration is particularly characteristic. Against the background of a garden wall over which violet wisteria

tumbles in lush and lavish abandon, an irresistibly handsome, very-black-haired naval officer is ardently embracing a young woman whose vivid red hair falls excitingly back from the radiant face she lifts to his. He is in summer whites. His gold-and-black epaulet is that of a lieutenant j.g. (junior grade, a step above the initial officer's rank of ensign), a symbol of success in the strange, dangerous world of men at war. Her dress is dark blue, set off by crisp white ruffles matching his uniform, symbol to my adolescent eyes of her feminine submission to his virility. His hand pulls her toward him. His smile is less broad than hers; he has the restraint of strength in reserve. Her delicate hands, one behind his shining head (Jon Whitcomb always liked highlights) and the other tenderly clasping his neck, reach up to welcome him. A black bracelet echoes the black ribbon threading her white ruffles: black and white, death and life, love triumphant over death—for the moment, as he will return to war and she to waiting.

I believed in Jon Whitcomb's vision. When, in 1944, James Truitt walked into my life one winter afternoon in a naval uniform, epaulets on his shoulders, gold thread on his sleeves tarnished by years in the Pacific campaigns, I was prepared to fall in love with him. "Fall" is exact: like Alice in Wonderland, I fell out of my own everyday world into his, bedazzled.

May 24

At 9:30 this morning Senator James Jeffords of Vermont will announce that he is leaving the Republican Party to become an independent. His decision will break the fifty-fifty split in the Senate: the ratios will become forty-nine Republican to fifty Democrats plus one independent. Vice President

Cheney casts a vote only in case of a tie, perhaps now a little less likely.

May 25

Twining Court will turn into its final phase—if all goes well—this weekend. *Swannanoa* (2002) is well begun. As are four *Parva*s.

I used to listen to a lovely cacophony of birdsong while I worked in the studio early in the morning. This morning, only a few squawks—not song—faraway. A black crow was enthroned on the fence near the pink clematis leading to the studio when I opened the kitchen door. It observed me calmly and took off, leaving me bullied below.

Human beings might be failing as a species. We have always killed one another. And now we have begun to turn against the planet, to despoil its plants, to hollow out its minerals, and to heat its atmosphere in a way threatening the proportions of water and earth.

Perhaps—I hope—Senator Jeffords's courage will ratchet the Bush administration's headlong rush backwards to a time before our realization that our planet is alive, like us, and our responsibility.

May 26

Today I am driving over to spend the night with friends in Easton, the little town on the Eastern Shore of Maryland where I grew up. I look forward to reaching the apogee of the Bay Bridge and seeing the line of Maryland flat against the Chesapeake. As sensuous a line as land and water can draw, but I miss the humble way

the old long-serving ferries used to slip into the very land itself. Embraced by two pilings, two semicircular curves of wooden, weathered pale gray. These timbers made a unique noise when the ferry nudged them, a deep, creaking, long groan. I used to hold my breath.

The Eastern Shore was well and truly isolated in my childhood. Alone between sea and sea, and further differentiated in particular ways: crushed oyster shell roads; pale whites, yellows, tans, and grays, sharp to your feet but tender to your eyes blending into marsh and field; surely the most beautiful of all roads, by rusty iron hand water pumps sticking out of raw dirt near farmhouse kitchen doors, outhouses with little half-moon slits, by wagons drawn by horses clop-clop-clop-clop. And in the autumn by the harsh-throated cries of wild geese going south, throbbing flight after flight. Isolated too by pride. The sort of tacit pride that George Eliot and Thomas Hardy so well understood, solidarity with a place beloved.

Still beloved by me, conceived there by foreigners (mother from Boston, father from St. Louis) and exiled since the age of thirteen.

EASTON, MARYLAND
May 27

Soon after leaving Washington I could scarcely see the highway through the rain, often couldn't see it and simply navigated by the lines, sticking to the slow lane on the right side. I thought to myself, "I shouldn't be here," but I was. Many of the cars whizzing along were not plain automobiles like mine but looming rectangular vans, virtually trucks for families. I crossed the Bay Bridge unable to see more than a few feet on either side.

Being here in Easton is worth the effort to get here. At dinner last night there was talk of changes. The rivers no longer wind between low grassy banks in a continuous gentle meeting of land and water, but all over, they said, have been chopped into sections and chewed up, time-honored houses demolished and replaced by "mansions." National and international chain-store companies have erected big industrial boxes on fields cleared by colonial settlers and ever since open to the sky. The families who settled here around 1631 have been tenacious; their fate is to watch their own demise, landowners displaced by land spoilers.

Displaced but not deprived of place: they carry their own place in their own bodies. Willa Cather wrote that "the history of every country begins in the heart of a man or woman"[17] and remains there. All of us at the table had lucid visual memories. We could "go back" and there we were, we still living, others dead, but all alive in common memory. Perhaps people who are less anchored have more they *could* remember but less they *do* remember. And there was a kind of reinforcement unified in last night's conversation. "The '20s and '30s were . . ." and Tom's voice trailed off into a smile as he spoke of riding his bicycle around Easton as a boy, of an ice cream cone (double dip), of visiting his cousin James, the president of the Eastern Bank, who used to deposit a fifty-cent piece in his palm as he shook hands. He spoke of how when he was a boy of two or so another cousin, very, very tall and thin, used to lean way down and in a deep voice bid him "Good morning, Mr. Bartlett."

We remembered yet another cousin, our contemporary, a beloved single child who died abruptly in his twenties of a brain tumor. He had red hair and translucent blue eyes, and was lithe, young, and blessed with all life could offer—except, in the end, life.

This morning I go to the cemetery to put flowers on the graves of the well-remembered before driving back to Washington.

May 28

Mother and father once owned a plot in Spring Hill Cemetery in Easton. They sold it after they moved to Asheville, North Carolina, and bought one at the Calvary Church in Fletcher, near Asheville. There they lie, side by side, on a grassy hill overlooking the Great Smoky Mountains. I will join them there. None of us belong to that place, but I belong to them and they to me.

The Goldsborough plot in Spring Hill Cemetery, at the end of Hanson Street off Goldsborough Street, is easily recognized from a distance: overlooked by an ancient tree to the east and enjoined by young trees to the south. Helena's daughter and I bought that tree together, from the son of friends of her mother's, who has a nursery right across from the Tred Avon backwater, next to the house where I spent Saturday night.

I distributed flowers among the graves of those whom I cherish. Including some for the short space where Anne, Helena's older sister, lies. Anne died while Helena was a newborn infant at the Maryland Hospital for Women, in the same nursery into which I would be carried two and a half years later.

Helena's is the newest headstone, still bright white marble. I leaned against it, rested there, and thought and said prayers, though benign divinity has no need to be prayed to, all always being well.

As I drove slowly out of the graveyard, past names recognized as faces remembered and names unknown and names smoothed indecipherable by years and moss and weather, I felt

for the first time since Helena's death that this is where she belongs, in her ancestral place.

WASHINGTON, DC
May 29

Jem Cohen has just been awarded a Guggenheim Fellowship. He makes videos. "I'm not even forty," he said ironically at lunch yesterday, "and they're already giving me retrospectives!" We both laughed. We met at Yaddo in 1989 and will meet there again in October.

Some years ago Jem made a film about Germany so chilling that I would be reluctant to see it again, though I would because of its fidelity to the wise eye. He returned twice to Germany this past year, but neither as a Jew nor as a man has he ever been able to relax there. Something of evil remains. In the cities he finds himself less uneasy. We agreed probably because they possess potentiality to escape notice while under sentence of death if discovered. In the countryside he is uneasy. Surprising, but a fact: as if the land itself had been drenched and needed time— Jem thinks two or three generations—to dry out.

Michael Novak was here also: we edited together his proposal for a book on Frederick Hart, the local figurative sculptor who did the work on the National Cathedral's façade, as well as the *Three Soldiers,* added to Maya Lin's inspired Vietnam Veterans Memorial because people missed pictorial representation.

Michael Brenson came this morning to ask about David Smith, on whom he is writing a book. He will return in July because we found so much to talk over.

Michael remarked that David had died untimely young at sixty-five. I demurred. It seemed to me that people die when

their lives are finished. Pierre Teilhard de Chardin once wrote that we are spiritual beings having finite physical experiences.

Tom's cousin died, I have to accept, and little Anne too. Either we are born into a logical schema or we are not. We choose to try to understand—though we cannot, ever, in entirety—or we embrace meaninglessness. Perhaps that decision, in the end, is a matter of temperament.

Sadness is inevitable. Acceptance is not inevitable. It only feels to me larger, wiser. I wonder what David would have thought, and wish I had talked the matter over with him. The great body of his work ended with the *Cubi* sculptures. Culmination and finale, to my eye, of the Cubist tradition. To the very edge of rhetoric, not beyond. Enough.

I continue to miss his bristly, pure presence. So few artists have indomitable confidence. So few the strength to afford tenderness.

May 30

I plan a domestic day punctuated with work in the studio, the end of a phase of *Twining Court* and the continuing of the other sculptures in progress. I am preparing for my cousin Alice to arrive from Boston on the second, and relish making arrangements for her comfort. I am so thankful to have been born a woman, to have a cave of womanhood to which I can retire, for the relief of chores entirely familiar, guaranteed to be within my ability to do well. Work in the studio can never be successful. "Between the idea and the reality," T. S. Eliot wrote, "falls the shadow." Always a haunting gap between concept and actualization.

June 1

Sam just telephoned from the Newark Airport. He is about to board a plane for Las Vegas. Another disjunction, he remarked, in a life of disjunctions.

I: "What looks like disjunction may actually be junctions on a causal plane not otherwise accessible."

Sam: "Naturally. The poetic continuum."

June 2

A message on my telephone machine this morning: a man in Maui wants to send me a kit and a video about the work in art that he is doing; if I want him to, please call an 800 number. A sunny voice: "Have a good weekend. Aloha!"

When I landed in Honolulu on my way to Australia in 1981, my plane was grounded for seven hours. Another Pan American aircraft, inert in the Fiji Islands, needed an engine. Mechanics swarmed around and affixed a fifth engine to our plane, tucked it in between one of our own engines and our body. No excuse was made for this delay. Those of us who had flown the Pacific before—this was my seventh crossing—needed none. We had got used to odd interruptions, unscheduled landings on minute atolls for more gas and the like. I felt the special freewheeling of the Pacific, the unity of virtually limitless space. I listened with pleasure to the easy laughter and gossip of "old hands" sprawled around a circular wicker table cluttered with glasses and ashtrays.

Our takeoff was careful. We lumbered for a long while down the tarmac, finally dragged up into the air.

My cousin Alice is due to arrive tomorrow at noon. We plan to drive to Annapolis for lunch with Mary and John and

their children. Charlie is in Paris for the summer, working for the *International Herald Tribune*.

June 3

When Alice got out of her taxi and came up the front steps toward me, I saw that she looked like Aunt Nancy: overall shape and size and color. The same bone structure too: the high broad forehead that runs through the family. We are third cousins; our great-great grandparents were brother (Captain James Collier) and sister (Elizabeth Collier). Later, in the course of our running conversation that ranged wide and lasted late, Alice remarked on the startling resemblance of her first cousin's daughter and my sister Louise's daughter, Lisi; she had mistaken one for the other at the recent family reunion.

It was Alice who initiated and shepherded this gathering of the Lincoln-Collier descendants. We met last August in Hingham, Massachusetts, where Alice and her husband Ware live in a wind-weathered house overlooking the town bay and beyond out into the Atlantic Ocean. A house entered by the most hospitable steps I ever walked up: low, broad layers of board so before you know it you are in the house itself.

Sixty-two people came from near and far. In the video that Alice brought with her, our group could be considered from a botanical viewpoint as constituting one proliferating entity, like the aspen clones in the Wasatch Mountains of Utah. A little European child adopted by one cousin; Sam's wife Flo, a French woman, is another ilk; and here and there others declared the autonomy of individual choices introduced into the family stream. Introduced and welcomed. Altogether we, gathered in a tent in the yard, are a good-natured and affectionate clan.

And so we should be, linked and nourished by generation after generation of prudent men and women.

We told tales of past and present in an easy antiphony of three generations. If there were indeed a common psychological denominator, it might be, as Alice remarked, an affinity with language. Even the youngest appeared to say what they meant and to mean what they said. Perhaps self-confidence also was common among us: we stood sturdy on our feet.

This description might fit any family reunion. *Wild Strawberries* had a similar key, the key of history caught on the wing.

June 4

Actually, life in general begins to look to me that way: sometimes I hover over my own head, almost as much observer as actor. Alice and I must sound like Joyce's Anna Livia Plurabelle's flowing river voices. Having lived practically the same number of days, we enjoy what is for me a unique mutuality. I have observed this elusive intimacy in my twin sisters ever since I first saw them, Louise in a crib, Harriet (because only one baby had been expected and she was born second) in a wicker laundry basket. No matter how vociferously the twins fussed with each other in their perambulator, some tacit unanimity remained and has underwritten their lives. I have long envied their companionship—more than I was willing to admit to myself, to judge from the pleasure with which I welcome Alice as my "twin."

Lunch with Mary in Annapolis. We, as if in an Impressionist painting, sat in the dappled light of the trees swaying over the deck. Max, the new mastiff puppy, has dug a large round hole in the garden below. Sometimes he walked through the muddy water, sometimes he drank it. We all looked at him affectionately:

plenty of time for Max to grow up and plenty of ground for him to dig up. But Mary pointed out, as I saw with a pang, that Max's eyes are without much spark. Mastiffs are called "gentle giants." He may be like the giants in fairy tales, impressive and dull-witted.

June 5

Last night we dined with two of Alice's grandsons and their father. Lively, informed, witty conversation—references flying like tennis balls hit across the round table. Jay, one grandson, is writing an account of the recent history of Eastern Europe. We discussed Hungary in particular. Jamie is in the office of Senator John Kerry of Massachusetts. I have for a long while had my eye on him for president and listened carefully to what Jamie had to say. Their father discussed the 2000 election, a masterly summation.

Alice and I spent the morning at a restorative exhibition of Grandma Moses's paintings at the National Museum of Women in the Arts. Wilhelmina Cole Holladay bought the Masonic Temple on New York Avenue (the site of the Institute of Contemporary Arts where I studied sculpture for nine months in 1949) and opened the museum in 1987.[18]

I disagreed with her establishment of a ghetto for women: Justice Sandra Day O'Connor recently remarked that the factor of gender was irrelevant to the cogency of legal decision. How could a woman's judgment be less or more valid than a man's in matters as abstract, as universal, as the weighing of justice? Just so in a matter as abstract, as universal, as art.

There, however, has endured Mrs. Holladay's museum with the validity of survival. It has been kept going by earnest effort, and I have come to understand that it aims to honor earnest effort.

Grandma Moses was born on a farm in New York in 1860, married a farmer, lived with him in the Shenandoah Valley of Virginia where she gave birth to ten children, five of whom she buried before returning to upstate New York where the family finally settled. She lived to be 101 years old. She liked making things. She made butter. She made preserves. She made paintings. In 1938 an art collector spotted one in a drugstore window. In 1940 she had a solo exhibition at the Galerie St. Etienne in New York. Title: "What a Farm Wife Painted."

What a farm wife painted was what a farm wife saw: mountains in the background, chores and occasions in the foreground: cider-making, riding in a sleigh to go visiting in a blizzard, catching a holiday turkey, quilt-making, the view out a window. She had no trouble with pictorial space because she apparently never thought about it at all—she simply recorded what she saw, and this simplicity saved her from the curse of amateur work: the "laws of composition." If she decided to put in a skipping child, she did so where feasible. She delighted in movement and color. Her playfulness is irresistible: What will she think of next?

She started a painting at the top, she said to Edward R. Murrow in a video we watched, and "painted down." Sometimes, rarely, she changed the position of her eye. Mostly she just looked right out: everything interesting was equal to everything else interesting. By anchoring the paintings at the top, she could afford a lot of action below, and she anchored that with color; in a sense her paintings are literal horizontal slices of life.

June 6

A doctor's appointment at 8:45 a.m. forced me to choose between washing my hair and starting the coats of paint that

will finish *Twining Court*. I chose the paint. As I put it on I recognized how this sculpture, named for my studio in Twining Court, has recalled me to a certain technical coarseness characteristic of the work I made in that studio in the early 1960s. That on the one hand, and on the other a way of layering color I evolved in the late '60s in paper works I made in Tokyo.

Before Alice got on the plane to go home yesterday she told me that she did not at all understand my work and asked me to explain it. We walked out to the studio and around the sculptures standing there. "Do touch," I said, so she could gauge for herself the way in which the surfaces change as they absorb undercoats of white and, finally, color.

We looked at *Twining Court*. For once in my life, I talked about what I was aiming for, about how the scarlet ceiling locked into the scarlet floor, taut along scarlet lines against dense black—how that was my life in the early '60s in that alley studio.

"But I still don't understand what you mean," Alice said, and I could see what it cost her to be honest when she could perfectly well have lied.

I felt a moment of despair. Then, "Move over here," I said, turning us away from the sculpture so it could be seen from a new angle and at a distance. "Oh!" she gasped, and I knew it was after all alright. But it wasn't.

"I still don't know what I am expected to be looking at. What I'm supposed to understand."

"You already did. That's all there is—that gasp."

"You mean I'm not supposed to know that I'm looking at something I will immediately identify?"

"Yes."

"Oh," a pause. "Well, that's alright then."

Was it? Neither of us were, I think, entirely sure.

She refused the help of a porter at the airport, grasped the

handle of her rolling suitcase. My last sight of her was her straight back as she walked into the airport as decisively as her ancestors must have walked into the ship that was to take them over the ocean to a new land.

June 7

Margot and Jim Backas picked me up at six for the opening of Helen (Leni) Stern's "Pretty Flowers" in Georgetown. Her drawings are at once practical and imaginative, like Leni herself: clear color and serious lines. We have been friends since the summer of 1957. The night before James and I set out to cross the continent and settle in San Francisco, we leaned with Leni over the railing on the roof of her future husband's house and watched the Fourth of July fireworks burst into the eastern sky toward the capitol. We like to reminisce about that evening, the soft southern night air, our thin white cotton dresses, and how fresh we were—*en fleurs*.

By now we see such familiar pentimentos, familiar behind our current faces. Pentimentos spring into focus behind wrung faces at the exhibition. A staid and distinguished old man used to enjoy bopping balloons about in the air against the low ceiling of the cramped apartment he lived in when he arrived here, in his very early twenties, Lochinvar out of the west. One woman whom recollection had frozen at the age of thirty has filled out her silhouette in ways I can see are logical; her husband is as busy as he always used to be but his hair is white. We are become what we once pretended to be. Myself too, still in cotton, wearing flat shoes with hair just hair on my head.

And last night in Leni's grandchildren I saw the future we have lived out beginning again . . . The straight narrative of lived lives.

But later, in Margot and Jim's candlelit dining room, with vichyssoise, fennel and apple salad, strawberries, the season's first sweet peaches swathed in thick cream and rounds of shortbread cookies tucked under, the narrative seemed worth it! There are friends by whose presence a life is measured. Margot and Jim are such friends to me. Though they are younger than I, when I am with them I feel something of the freedom of a child who is intelligently watched over. Both have just retired: Jim was director of the Maryland State Arts Council, Margot of many programs critical to the achievement of the National Endowment for the Arts.

We enjoy the triangle made by our points of view about art against a background taken for granted. Last night Jim told a story about Toscanini: A composer sent him a score. Toscanini returned it without comment. When they met some time later, the composer asked why T. had not commentated—other people, he said, had thought the music "not half-bad." Toscanini: "Would you eat a half-bad egg?"

June 9

Blue-water sailing. If the work in the studio were a ship, her prow would be parting the sea one glittering day after another. Navigating toward three ports and a charted future: a solo exhibition at the Sheldon Art Gallery in Lincoln, Nebraska, in the spring of 2002; a group exhibition at MOCA, the Museum of Contemporary Art in Los Angeles, in the spring of 2003; and a solo exhibition of sculpture in my New York gallery, as yet unscheduled. Every evening I go to sleep in the knowledge of a little distance covered, and every morning I wake into the prospect of a day's journey ahead.

Perhaps it is only in such a context that some insights can be afforded. Certainly I was taken by surprise yesterday morning to hear myself on the telephone bullying an indecisive acquaintance in a horrid hard voice. I bore down as if on a toad beneath my barrow. No sooner had I hung up the phone than I began to feel sick, and this morning I see that the toad I unearthed was in itself the ugly shape of a self-righteous know-it-all. Jung would say that my shadow—his name for the dark, secret, mean part of a personality—had emerged. The shadow must be recognized, he says, if a person is to grow. A painful recognition, he adds, pain in this case adumbrating the release of truthfulness.

June 10

Twining Court is finished. There it stands, its own self. As if it had never not existed. I look at it and see something I always knew was there but never saw before.

Swannanoa has only three more undercoats to go. I will mix its color on Tuesday this week. The work next to it is undercoated, as yet unnamed, but still coming along: color mixed in a glass bowl and another color in a glass jar nearby. Four *Parva*s are starting out. One is for Alexandra, who says that she will drive down to pick it up when it is finished.

Charles Desaix remains in my mind: "Still time for another battle."

But a complex combat. At eighty, is my time running out?

In the meanwhile, skirmishes are sometimes sharp but blessedly familiar. Do I take the daily walk—that I am told will keep me going—when every step hurts? Do I succumb to the soup-and-toast syndrome or make risotto?

Still time for another work, and another . . . to see another chapter in the lives of those I love, to finish the work I am doing now plus the work waiting in the wings plus the work I plan to do at Yaddo when I go there for five weeks on September 24 . . . to watch another sunrise, sunset, eat another peach.

The familiar is manageable, but it is precisely the familiar that is due to meet the cutting edge of death.

Sometimes, perhaps in a curious kind of anticipation, things feel unreal.

Occasionally things feel a little unreal anyway. I seem to "come to" and find myself thinking, "What am I doing *here*?" Just this morning I suddenly stopped on my way downstairs: Who is this woman holding a glass in one hand and the railing in the other? I scarcely recognize her.

When a tree is very old, it parts easily with the earth. And sometimes leaves behind the glistening stems of the new tree it had made while it was dying. The new life of a person who is dying can only be in the spirit. A secret, unknowable life, known intuitively only by the dying and only fully by the dead.

I am healthy. I have time. Now and perhaps for many more years. But I cannot know how long I will be as I am now. And whatever the timing may be, I am placed somewhere in a cone narrowing toward the point of death.

June 11

Sun Tzu wrote *The Art of War* around 500 BC. A general experienced in leading an army out of tight places, he says that "if you hope to come out of the pocket the same man you were when you fell into it, you will die. If instead you are able to consider yourself dead you are already transformed."

He goes on to say how each soldier must face the fact that his situation is hopeless. He must clear his decks, pay or forgive his debts. He must gather himself together, make sure that he is in good fettle, well fed and with weapons in order. Thus he transforms himself from a person who aims to hang on to the piece of land on which he stands into a person who aims to advance into the unknown, no matter what. "Let the drums roll ferociously."[19]

It's ignominious, I think, to *hang on* to life.

June 12

Word is that a publisher intends to edit C. S. Lewis's Narnia books, to eliminate "the religious part." To eliminate its animating force, Aslan, the great golden lion whose body is warm and strong, whose mane is soft and thick, whose sweet breath heralds his appearance.

Charlie and I love Aslan; I read the whole series to him when he was around four and used to spend one night a week with me because Mary had to spend that night in New York, where she was getting her MFA in creative writing at Columbia.

Aslan and Prince Caspian and our favorite, Reepicheep, the valiant warrior mouse. Eustace, the disagreeable boy who goes to sleep spread-eagled on the ground one afternoon and wakes to find that he has turned into a dragon. When transformed by this experience he joyfully turns back into a boy. In Aslan's world transformation proffers growth. His presence guarantees it.

Yesterday the perpetrator of the devastating 1997 bombing in Oklahoma City was executed. In its turn, the state has killed. Annihilation, the opportunity for transformation denied.

June 13

My mother's death was a battle. I stood beside her bed, one hand on her shoulder and the other on her knee, bridging her body with mine. Only nineteen, I had seen death before and was aghast at such sheer power. I knew that my mother knew she was dying, and in the few words she spoke I recognized the tender serenity of her spirit, perfectly herself, perfectly easy on her appointed way. Yet her body adamantly refused to give her up. It was like a duet—now high and sweet, now low, deepening and reverberating. Over and over I prayed: "Now lettest thou thy servant depart in peace." Finally, after many, many harsh deep breaths interrupted, her body set her free. I felt her relief as she lifted away.

June 16

A museum is offering me a solo exhibition scheduled for some time in the future. Scheduled, I was told this afternoon, to coincide with repairs to the museum, hence to be confined to one gallery, one without natural light.

Nothing in me quivered. I just said, without fanfare, that I would prefer not to show while the museum was being repaired and would prefer to show with natural light.

June 17

Coffee is particularly yummy this morning because I am drinking it sitting up in my bed with my notebook after mixing the dark red/brown for *Essex* (which I am restoring for Marcella Brenner)

and putting it on the bottom. Leaving the signature as it is: inscribed on a rough patch of black, "Anne Truitt 11 April '62."

Very early days. I was still using my first name, still writing my signature just a little tentatively, still putting in the day. By 11 April '62 I had added the Twining Court studio to the one across the street from our house on Thirtieth Street. Bill Lawrence, who ran the mill of Galliher Brothers Lumber Company at the foot of Thirtieth, where it ended in the Potomac, had begun to fabricate work for me.

I am learning from thinking about those days in the early '60s. It's as if my younger self were pushing me along, her energy bursting into the rather stately stream that mine has become. She seems to have decided that if she is to make what she has always intended to make, she'd better *act*.

And as I mixed *Essex*'s red this morning I suddenly dropped the preoccupation with age that has lately been bothering me. I feel young. That thoughtless vigor. Now that I have thought it through, it occurred to me: I recognized that I am going to die at the end of this indefinite period of my life; decided how to handle matters if disabilities force me to leave my house and studio; taken Sun Tzu's counsel, cleared my decks, psychologically jettisoned what I can and focused forward. So be it.

June 18

A folie à deux, a mutually constructed context to which two people acquiesce and from which their actions derive, is common. Perhaps it is to some degree ubiquitous in all long-standing relationships. Even an intimate friendship becomes a territory with boundaries that develop one way or another over the years, and are respected for good reasons. A marriage particularly.

Apparently a folie à deux grew like a monstrous fungus under the ground of William Butler Yeats's marriage to Georgie Hyde-Lees. He was fifty-one in 1917 when they married, she twenty-four. Within a few days, their common interest in spirits blossomed out of a sexual tangle: Yeats asked questions of his wife and she replied in a mediumistic trance. The tangle unsnarled. They increasingly regulated their life together by way of this communication.

I have been reading about this extraordinary situation—they asked their attendant spirits when they should make love—imagine!—and wish I hadn't started. Some line of decency is crossed here. In the righteous name of literary investigation a private source of Yeats's intellectual poetic formulations is analyzed and found to be rooted in a sort of sexual/spiritual conspiracy. Yet traffic with attendant spirits may, at a certain level, constitute spiritual aspiration. I cannot help admiring the invention and pursuit of a modus vivendi that must have cost them both dearly.

And Yeats's poetry remains transcendent, as a life can never be.

> How but in custom and in ceremony
> Are innocence and beauty born?

Not *always* out of "custom and ceremony." And not *always* should the territory of a friendship be respected.

Twice Margot has had the moral courage to cross the boundaries of ours. Thus twice we have changed, enlarged, its parameters.

June 19

But such changes can be natural only when good will can be taken for granted and when intelligence as well as affection is brought to bear. Today I met head-on what was pretty apparently ill will locked into an obstinate mind. I am "pulling my chestnuts out of that fire," but it is a fire at which I have warmed myself for some fifty years. I am sad.

June 20

At last, I have come across a description of what happens to one when a work suddenly emerges out of its own cocoon of its own accord.

Yeats: "I was going along the Strand and, passing a shop window where there was a little ball kept dancing by a jet of water, I remembered waters about Sligo and was moved to a sudden emotion that shaped itself into 'The Lake Isle of Innisfree.'"[20]

Exactly: "moved by a sudden emotion that shaped itself . . ."

"Muses," Yeats wrote Ezra Pound, "resemble women who creep out at night and give themselves to unknown sailors and return to talk of Chinese porcelain."[21]

The "sailors" best remain "unknown."

Curiosity can be prurient, analysis irrelevant. To artists ever deadly, the mind being so nimble yet so eager to *know,* to reach an emotional resolution that can freeze-dry an impulse into comfortableness. The leap to "Chinese porcelain" has to be taken over an abyss of unknowing.

Summer

June 25

Home from the ocean. Mary invited me to be her guest for a
few days at the beach—her husband John thought she needed
a little vacation after she finished teaching. So over the Bay
Bridge we happily drove and on to the Blue Surf Motel, where
we settled ourselves into a familiar routine.

Sunrise (drinking hot coffee!) over the long smooth hori-
zon into perfect morning; dolphins (Mary says they have to be
called black scimitars cutting pewter waves); beach reading
(our "cheesy books"); eating what we don't usually (very hot
crispy fries out of paper cones); conversation.

Observations: how a certain "key" of light begins and ends a
day in an intimation (Mary remarked) of perfect munificence.

Mary also marked the key of what we watched from our
second-floor balcony: people moving, moving, moving, on the
beach, on the boardwalk, in the ocean. If looked at just as a
species, she noted, we were an *affectionate* species.

June 26

Excerpt from a letter to Quentin and Mark Meyer, June 2001,
with reference to the disposition of the sculpture *Two*, which
Quentin and Mark inherited from their father, Cord Meyer:

"Cord bought *Two* from me for the sum of $100 in 1962, the
year that I made it. He particularly wanted to have it because
it was made with him and his twin brother in mind. I have twin
sisters, which makes me sensitive to what it is to have a twin
brother, and to lose him in the terrible war that they both fought
as young men. Their lives ran closely parallel, and Cord's grief
must have continued to run like a dark thread in the life that he

had to live alone after Quentin's death. In *Two,* I discovered for the first time that I could counterpoint form and color as a metaphor for the meaning of a work of art. The two elements of the structure are not perfectly symmetrical, as no two human beings, no matter how unified by birth and experience, are exactly alike. The two colors, dark green and black, also reflect this inevitable difference in that they counterpoint each other, as in music, within the unity of a single sculpture. The meaning of the sculpture lies in this counterpoint of unity in life and separation in death, refracted by way of this specific instance but by extrapolation signifying the ultimate unity of all human beings in both life and death, inseparable in divine order."

June 27

The catalogue of "Intimacy and the Creative Pair," Owings-Dewey Fine Art, Santa Fe, New Mexico, has arrived on my doorstep. I have been reading Jonathan Weinberg's essay and looking at the paintings assembled by Nathaniel Owings and Laura Widmar. Nat is an old friend in the sense of having known him for many years; his father owned land near ours in Big Sur, and through this connection Nat visited us in Japan in the mid-1960s, when he was a young man. In October 2000, while I had an exhibition on at the Georgia O'Keeffe Museum in Santa Fe and in addition was teaching a workshop at the Santa Fe Art Institute, he showed some of my sculptures and works on paper in a two-person exhibition with his wife Page Allen, a widely known Santa Fe artist.

The catalogue is perfect, as Nat's catalogues always are, and next best to walking around looking at these provocative

twosomes. I do not find, however, that looking is challenging my deep-rooted distrust of any kind of sovereign relinquishment in art—no matter how loving. And, it seems to me, it is unfortunate that the test of love is not the degree to which it is intimate but the degree to which it sets the beloved free into inconceivable and unpredictable individuality.

Though a cliché, it is a fact that we are born alone and we die alone. In between, we develop what we were most personally born with into what we most personally die with. Our deepest intimacy is that which trues us on a spiritual plumb line with the force from which we came and to which we go.

These couples engage me only briefly. My eye leaps to one or the other artist. The work of one seems, in Clement Greenberg's phrase, "to criticize" the work of the other. Stieglitz's *Winter, Fifth Avenue* blows away O'Keeffe's *Portrait of a Day*. Pollock's *Number 27, 1949* sucks the air out of Krasner's *Collage, 1955*.

Weinberg writes of the latter pair: "Works like *Collage, 1955*, made up of Pollock's mark making, find Krasner reconsidering Pollock's signature drip. She cut up some of his old, presumably unsuccessful ink drawings and reassembled them to make a new surface for her own brushwork. [. . .] Out of failed work she made something new and whole."[22] Not to my eye: she made something muddy.

By 1955 (he died in 1956) Pollock had virtually stopped painting. But he was still *alive*. Imagine the sheer impertinence of Krasner's recycling certain of his works she apparently took it on herself to decide were "unsuccessful"!

Weinberg is impertinent too. His "mark making" and "signature drips" are cheap shots.

June 28

The marriage of Robert Motherwell and Helen Frankenthaler seemed to be ideal. Both artists of stature, equal in talent, age, health, energy, and success. On the left of the fireplace in the living room of their house on East Ninety-Fourth Street, a marvelous Frankenthaler; on the right, a marvelous Motherwell. Perfect. But when I was in that house I felt ill at ease—as if decanted onto a stage without a script. They had thought about everything. Even the food was special, especially cooked by Bob the one night I had dinner there—they were taking turns at learning new dishes.

Yet I was glad to learn from them. Helen had figured out how to be "a great artist," how to balance herself in that position. Bob must have figured that out long before I met them: he kept a distance that seemed natural to him. He was wonderful to be with because he read avidly, and thought.

It was Bob who put me onto one way of thinking about how place influences people: they never forget, he once said, what they saw when for the very first time they opened their eyes to the lay of the land around them. If I consider two paintings of theirs that might have been chosen for the Owings-Dewey exhibition, I visualize two of equal "quality," neither criticizing the other. But Frankenthaler and Motherwell were more individual artists than they were a couple. And, in the end, they separated.

June 29

Charlie telephoned from Paris yesterday afternoon, 8:30 his time, 2:30 mine. (His hours at the *International Herald Tribune* are from 3:30–10:30.) He stays late (we like to discuss our daily schedules!), writes, and has breakfast at Les Deux Magots: a whole melon, an

almond croissant, and café au lait. Work. Afterward, he meets his college roommate, with whom he is sharing an apartment on the rue de Verneuil, parallel with the Quai Voltaire and rue de l'Université, near the hotel where I stayed in 1984. They repair to the Café du Dôme and drink white wine. We gossiped about the Left Bank, where he is living: he visited St-Julien-le-Pauvre the other day, and will return to the Musée de Cluny very soon, goes often to Shakespeare & Co. and sometimes to the W. H. Smith bookshop and tearoom on the rue de Rivoli.

Sammy is in Kansas City. Alastair is driving across the continent from California. Alexandra and Jerry are going to Turkey for August. Sam is thinking about major changes. Mary is set for a summer at home. And heaven knows I am—a happy summer, one hot purposeful day after another. I like to think of my family here and there on the face of the earth. For myself, the Irish proverb: "May no new thing happen." Or only one anyway—my new sculpture is, I think, called *Nouvelle*.

July 1

A foundation has asked me to recommend an artist for a fellowship. I have been at pains now for two days to write a balanced letter. An enthusiastic recommendation writes itself. But I have had an eye on this artist's work since the early '70s, have never found it anything more than "inventive," and cannot in honesty recommend her. As I weighed the many pages of her resume I kept seeing the image of a skein of water over a wide landscape, a shallow pond reflecting a colorless sky. When time brings the sun out the work will evaporate. An active life in art can preclude profundity.

But these words embarrass me. As if I were myself smugly apart from such dangers—which I am not. Within the last

months I have been rapped sharply by the results of two of my actions. Hell may indeed be "paved with good intentions." Mine were good from the beginning, and remain good to this day, but I made trouble for one friend and had to act a lie to the other. I have apologized for the first. The second remains a secret lie, and has damaged no one but myself. Candor is the breath of friendship. I will simply have to live out its betrayal in this case, a sick feeling only offset by the absolute resolution never to embark on such a course again.

I spent most of 1984 as acting director at Yaddo so that Curtis Harnack could take a leave of absence. One of the lessons learned there was to practice restraint, first as a pragmatic tactic, and then as a source of balance. I learned to run an eye over things but, in general, not to touch. I feel rueful not to have remembered a lesson that cost me so much to learn.

July 2

I was standing on the front porch last night about seven, resting a minute after finishing work in the studio and lifting my face into the cross-airs of a diminishing thunderstorm, when I heard a roar in the sky. An airplane came at me low over the house, slanting from northeast to southwest into and out of and back into layers of wind-torn clouds. Dangerously low, looking to be not much above the trees. The intense attention of the pilot lingered in the air, echoing the laboring engines as their noise faded out behind them.

* * *

The end of a sad day: Charlie's other grandmother died.

July 3

Yesterday a filmmaker came to talk to me about Morris Louis. Experienced—this is his second film on Morris and he has made others on other artists, some by invitation of the artists themselves—and engaging too. He would like to film me talking about Morris, but was polite when I said no.

I resist being filmed, have turned other people away too. Not by theory or even principle, perhaps a little by policy—the separation of church and state—but mostly by instinct.

On the other hand, instinct let Jem Cohen run his camera in Pigeon West while I was painting at Yaddo in 1999. But . . . Jem is a friend. And "a foolish consistency is the hobgoblin of small minds."

July 4

> To regard all things and principles of things as inconstant modes or fashions has more and more become the tendency of modern thought.
> —Walter Pater (1839–1894) in *The Renaissance,* 1873[23]

Nothing is as undated as moral indignation.

Pater's innocent enthusiasm is endearing. He reminds me of Clement Greenberg. Clem used to go by what he called his "take." The most lively companion to look at art with: his pleasure rose so spontaneously that it seemed to pull his temperature up with it.

Walter Pater speaks of this pleasure: "There is a certain number of artists who have a distinct faculty of their own by which they convey to us a peculiar quality of pleasure which we cannot get elsewhere."

This characteristic "seems to bring [them] very near to us. They bear the impress of a personal quality, a profound expressiveness, what the French call *intimité,* by which is meant some subtler sense of originality—the seal on a man's work of what is most inward and peculiar in his moods, and manner of apprehension."[24]

"Very near to us," and always and forever available—right there in their work! Best of all, they develop with us. When Alexandra and I were in the Frick Collection last spring, I saw in the Rembrandt *Self-Portrait,* which I have been looking at since I was in my twenties, a man I more clearly understood than ever before, as if he had been keeping pace with me personally.

I also saw how Rembrandt *let* the people in his portraits *be.* Hals cannot resist flourishing his magic brush over his subjects. Rembrandt sees and honors each so profoundly that he renders the specific universal.

July 5

My dear neighbor and friend has decided to intercept the progress of her mortal illness. She stopped eating six days ago. She lies in a sunlit room in her own house. Her dog lies on her bed, his head on her leg. Her children are here from points far away, and yesterday morning four of her grandchildren were clambering on the stairs.

Between chips of ice she spoke plainly of her death. We both laughed to think that I might be mistaken in taking for granted that we can move along calmly because our essence is the divine force out of which we arrived and into which we depart. If so, she said, she will be cross! But we are pretty certain that "all manner of things are well." Our bond is that we

have both lived a long while, have taken our chances, and on the whole have found life fascinating.

"What about evil?" she said. Trismegistus—"as above, so below"—and Plato—the concept that the world we know here is a reflection of another.

"I will miss you," I said, holding her hand in mine. We became friends only in the last year, but with no one else on earth have I been able to discuss death with quite the same . . . "pleasure" comes to mind, and pleasure it is, the pleasure of honest, forthright ignorance.

Irreplaceable, each of us is irreplaceable.

July 7

I plan to finish the restoration of *Essex* today. Yesterday I looked at it, and so the situation I envisioned in the early '60s has come to pass: the sculptures *do* have lives of their own and their history *is* recorded in their wooden fabric, as ours is in our bodies.

I went to examine *Two* yesterday morning. It needs cleaning. That black and that green cannot now with certainty be reproduced. The sculpture will go to Yale as it is now.

July 8

Alexandra and her son Alastair, home for the summer from the California Institute of Technology, are coming down on Saturday. Margot Backas will join us, and we will drive to Bryn Mawr College. Margot, who has generously undertaken to be my literary executor, wants to see my archive at the Mariam

Coffin Canaday Library. Alexandra will spend several days reviewing it with a view toward a catalogue raisonné of my work. The manuscript librarian will meet us, and we will take counsel together.

Last Friday Constantine Grimaldis telephoned from Baltimore: the Walters Art Museum is apparently thinking of inviting me to curate an exhibition combining my work with "ancient Chinese porcelains." Such a show strikes me as contrived. If the museum approaches me, as it should have begun by doing directly, I shall very politely refuse.

A friend, intimately known for forty-eight years, standing straight and looking me in the eyes as her long-ago mother must have trained her to do, recently held out her hand to me and said, "How do you do?" Her eyes were sightless: agates, the marbles we children used to call "aggies," the smallest marbles, the ones that looked like putty with minute colored specks. It is true that I may be able to work for many more years, and equally true that I may not. Those agate eyes could be mine in a millisecond.

July 10

I have just finished Michael Brenson's book on the history of the National Endowment for the Arts.[25]

It was a privilege to serve on the Endowment's peer panels. To join other working artists in choosing grant recipients. We were motley, called together from all over the continent to make specific decisions in our common field. We made decisions within the parameters of well-thought-out guidelines, based on information provided by the excellent staff. Long sessions of concentration, more comfortable before the move

to the Old Post Office building on Pennsylvania Avenue—the air was never fresh there, I used to come home with my head aching, dumb with tiredness. We agreed and disagreed—warm disagreement sometimes—but I do not remember a cross word. We were all equally intent on distributing the citizens' money fairly and to good purpose. It was unique to be welcomed by our government, trusted. We were at ground level, too, where we felt at home, as if in our own workplaces but with the exhilarating knowledge that we were actually helping other artists. A *convitatus,* one for all and all for one.

The individual artist's grants were miraculous. Two, in 1971 and 1977, literally *enabled* me to keep on working. The applications were unpretentious: names, addresses, slides. You were not asked to prove anything; your work spoke for you. The procedure had grace. And the grants could be parlayed: one could last for two or three years if plowed entirely into "generations" of work.

But no matter how impersonally conferred, privately granted money feels personal.

The Endowment grants felt entirely different: Americans were investing in me.

I felt that: taxes are sacrifice. I felt the responsibility of receiving tax money. I felt the honor, humbly.

The Guggenheim Fellowship is the grandest grant. In 1970 I was getting a divorce and bringing up three children and teaching full-time. I had applied, without particular hope, really just because it was suggested to me that I should. I got the news late on an April afternoon after work, and remember standing in the front hall with the telephone in my hand, crying.

That grant built my studio.

July 11

Walter Pater's moral indignation persists. Can current "art" actually be art?

A photograph of a number of sailors lined up on the deck of an aircraft carrier; a stainless-steel rabbit molded from a cheap toy; one hundred or so naked men and women standing, packed in rows; a photograph of a crucifix submerged in the artist's urine; a woman on a stage smearing chocolate on her naked body; a cow, butchered, positioned, and encased in plastic; a photograph of an act of anal intercourse; the excavation of a volcanic crater . . .

When I was teaching, I used to discourse on such projects for as long as it took for the students to begin to discuss what they thought the artist might be trying to convey. The steel rabbit, for example, I used to postulate might echo the ancient fable of the omniscient medieval hare, might be the heir of Dürer's rabbit, of the dead hare to whom Beuys spoke, of the dear little innocent rabbits in flowering backgrounds of Renaissance paintings, of Flemish tapestries. Here is the history, Jeff Koons might or might not be saying, that technology has rendered mute, a silly toy. So watch out: you may be too, or are as meaningless. So the foolish-looking steel rabbit becomes—in this entirely invented interpretation—all ironic exhortation.

And an honest woman beset by cultural limitations well understands the sheer anger made visible when that which seems to be all that society values her for is smeared with the sweetness by way of which she is ironically *devalued*. An honest woman might feel it but swallow the feeling. An honest artist, Karen Finley, thought of how to express it, and had the courage it must have taken to stand forth alone and naked on a stage,

and in outraging her audience give them some inkling of her own outrage.

* * *

My dear neighbor has died.

July 12

The sun has come up and I am glad to see it. I woke up at 2:35 a.m. and finished the ironing, put a coat of paint on a sculpture, made coffee, drank it, and now feel pretty tired—now, with the whole day ahead!

July 13

Yesterday turned out to be what it started off being. Even the paint I put on early in the morning was the wrong color. Sad all day. When we were children, my sisters and I used to call such a day a "soiled day"! The remedy: to have a hot bath and to go early to bed. So I had a hot bath, went early to bed. Woke up with the color I've been trying to mix for some days clear in my eye; mixed it; put it on *Parva LII*.

I've been thinking over the matter of government funding of artists, and if of artists, why not of lawyers, doctors, ecologists . . . ? Yet artists do make unique contributions to a civilization. The only Roman businessman I can think of is Croesus—because Horace wrote about him.

In Japan a very small number of artists are declared to be National Treasures, and are given a government income for as long as they live.

James and James Lee Byars and I were having lunch one sunny day in Kyōto when a National Treasure walked past us to the end of the wooden counter at which we were eating sushi. Dignity clad in a sand-and-tan kimono, silent. He could spin gold into thread.

July 14

Very, very few people want to spend a lifetime spinning gold into thread. But many, many wish to be artists.

W. H. Auden: "This fascination is not due to the nature of art itself, but to the way in which the artist works; he, and in our age almost nobody else, is his own master. The idea of being one's own master appeals to most human beings, and this is apt to lead to the fantastic hope that the capacity for artistic creation is universal, something nearly all human beings, by virtue, not of some special talent, but of their humanity, could do if they tried."[26]

WYNDHAM HOUSE, BRYN MAWR COLLEGE
July 16

We are here to examine the archive of my papers.

This early morning, when I looked up from the kneehole desk at which I write, I saw my face looming in the lower foreground of a gold-framed convex mirror reflecting and miniaturizing a formal room, as if in a Vermeer. I saw the settled face of age, though I felt myself to be living behind the eager face of youth here at Bryn Mawr. At that moment Alexandra came in, a newspaper in her hand. Katherine Graham, friend of many long

complex years, fell in Sun Valley, was operated on in Boise, and is in intensive care, in critical condition.

I walked out into the campus, onto the land where in the spring of 1941 I absorbed the news of my mother's last illness. The bell of Taylor Hall just rang. Summer students are bursting past me on their way to classes.

The past folds into the present. An unmeasurable weight.

WASHINGTON, DC
July 17

I walked into my house and straight to the telephone ringing. It was Liz Hylton, Kay's personal secretary, who in 1964 called me in Tokyo to tell me that Mary Meyer had been murdered. Now she said that Kay had died one hour ago at twelve o'clock.

Never again her decisive, strong, sometimes tart voice, behind it years of devoted friendship, speaking of particular mutual memories we so shared that their context need never be explained—really could not be shared with anyone else. Laughter too, casual laughter, natural relish of vagaries, oddities, characteristics, events. Kay remembered what I remembered. The past was solid fact to us both. We accepted responsibility for it, and we were equally interested in seeing the past as clearly as we possibly could, regardless of how it hurt. Few people are that tough-minded.

July 22

I have not been able to write a word.

But yesterday I had to speak. We gathered at the Friends
Meeting House to remember my neighbor Fitzy. The sun shone
in through windowed walls on her community, on her three
daughters and their husbands, and on their children, who at
one point stood up in the Quaker manner, said one sentence in
unison and sat down again in a row, loosely playing with bril-
liant silky shawls we all recognized as Fitzy's.

Because of having to have an English license, Fitzy had to
wait alone in London for three weeks before Gil, who was work-
ing in Paris, could be married. She learned to fly. An ex-RAF
pilot taught her. On the final day of the three weeks, she flew
alone. The next day she married. She never flew again.

This was the kind of story we told each other about our lives.
We met in the early '50s, and then in the late '90s, and not once in
between. So we became friends recently. Drank tea and ate cucum-
ber sandwiches and talked and talked: two Russian novels of
lives—families, landscapes, events, books, speculations, ideas . . .
and, of course, very little time because Fitzy was mortally ill.

July 23

The ceremony marking the end of Kay's life begins at the
Cathedral at 11:00 a.m. A cortege will wind south down St. Albans
hill to Georgetown, turn east on to R Street and on to the Oak
Hill Cemetery, opposite Kay's house, to which we will go for a
luncheon after she has been buried at Phil Graham's side. She
will lie for always next to her husband. Now all is said and done.

Sam did not come down. Alexandra and Mary arrived in time for dinner last night. These two women, lovely with the power of maturity: in homage to their right, I told, as I have not before and would like to never again, the tale of the years of our association, Kay's and mine, the almost melodramatic tale of how our scintillating, sick husbands had exploded in the sky right in front of our eyes.

July 24

I just waved goodbye to Mary with the blue index cards that someone had put on her windshield yesterday at the funeral to identify us as guests. Alexandra flew home. Today bids fair to be hot. The house is empty. Kay and Phil lie together in the earth. That comforts me, for both of them.

The bourdon trilled behind the first words of the burial service; Yo-Yo Ma's Bach illuminated it.

The stately cortege, a small group of black figures standing straight in the distance around the grave, the lofty medieval tents in front and back of Kay's house, the delicate lunch that we three ate under the great oak trees I first saw years and years ago when they began displaying the grand branches shading our small round table.

Ben Bradlee was the one person I most looked forward to seeing—the first person I saw in the chancel a minute or so after the service ended. Kay's children . . . Her world encircled for the last time by her own hand.

Kay herself, laughing. Under her picture, from the 1934 Madeira School Yearbook: "Those about her from her shall read the perfect ways of honor."

July 25

Last Saturday I only managed one errand after another. I was driving very slowly and carefully when I entered the parking lot of the post office. One space left, and in the center of it a bird. Motionless. Hot wavering light, as if a film had halted. Out of the car, I saw at once that the bird was a tiny, tiny new-feathered sparrow. A woman in red swooped in from the right and made vigorous noises. The bird hopped clumsily up to a neighboring fender, fluttered to the windshield, paused, and departed. The woman laughed. I laughed. We had witnessed a life begin.

I washed my hair in the middle of last night. The dryer is stuffed with clean sheets and towels. The lavender I got to cheer the house for Alexandra and Mary smells lovely. Order prevails, and late yesterday evening I put a coat of paint on a new *Parva*—just on the bottom, a small start . . .

July 26

I will be glad when this month is over.

Two months from today I will be, if all goes well, at Yaddo: Pine Guard, Pigeon West. The lakes, the trees, the foxes. And the staff, friends. A place *stays*. A *place* I can count on, can stay myself on.

Arthur Derby was my cousin only by marriage, the son of Aunt Nancy's husband's sister, Jane Barr Derby. He was mysterious among us cousins growing up on two adjoining tracts of Virginia overlooking the Blue Ridge Mountains. Remote, he moved smoothly. He was fastidious. I never saw Artie make an effort. Days flowed toward him and passed under his keel without trace. When the time came, he went to Harvard and there

acquired in his fluent way an affinity with Plato (my cousin Nancy and I were riding our horses near Aunt Jane's place one spring day and found him lying full length in the cool of a shallow brook reading *The Republic*) and a charming small touring car with his initials on it. One full-moon soft summer night he and his girl rode their horses up into the mountains, leaving behind my first impression of passion. But she would not marry him. He left Harvard, enlisted in the army, was sent to the Philippines, was captured by the Japanese, survived the Bataan Death March, lived almost to the end of the war at infamous Camp Cabanatuan. He must have been among the stronger prisoners, chosen in December 1944 to be slave laborers in Japan, and packed into the *Ōryoku Maru*.

He died of fever, at sea.

A fellow prisoner came to Aunt Jane's apartment in New York after the war and told her all this. A recent book makes me understand the course of events more clearly. But I have never been able to imagine how Artie managed to endure for so long under such cruel conditions. How, and why too.

He stays with me. Or I with him.

"Let the dead bury the dead." We must *let*.

July 29

The Champion Tree Project seeks out certain mighty trees remaining from the primeval forests that once covered this continent, reproducing them by way of genetic cloning. Science: a study showed that "a single large London plane tree in a front yard saved twenty-nine dollars in summer air-conditioning costs, absorbed ten pounds of air pollutants annually, intercepted 750 gallons of rainfall in the crown, cleaned 330 pounds of carbon

dioxide from the air, and added one percent to the sale price of the house."

Romance: "The champions are what the old-growth forest used to look like. What people alive on the planet see today are bushes compared to what trees used to look like."[27]

The Wye Oak in Wye Hills, Maryland, is a champion tree, one of my earliest memories: a great green mist (I was born nearsighted) filling the sky above my head. Some ten years ago I bought for twenty-five dollars an offspring of this ancient tree. Sam and I planted it in the garden and there it flourishes.

In Penland, North Carolina, about fifty miles northeast of Asheville, methane gases emitted by the former Mitchell County and Yancey County dump create power. Glassblowers and potters work on a tidy clearing atop the old landfill. "In a greenhouse, heated by methane, seedlings of native plants like rhododendrons and azaleas are grown for sale to local farmers."[28]

Elizabeth Gould investigates neurogenesis at Princeton University. She is a young woman and has three children.

When her first child, a girl, was born, just as her career was taking off, in 1991, she didn't see how she could continue to teach. "I had decided to put her in daycare and go right back to work," she said. "Then she was born and I fell in love with her and I thought she couldn't possibly survive without me. I was at this weird point of moving from a postdoc to the junior faculty and I had to write big grants to keep moving up, and for a while there I was just falling apart. My husband was really great. He said, 'You know, you worked so hard to get to this point, if you give up you are going to be miserable. You will feel like a failure.' If he had said something else—if he had said, 'Oh, it's terrible, I can see how you feel, why don't you take a

year off"—well, that would have been bad in the end. Bad for me, for my children, and for my work. I would have never been happy in my life if I had taken that turn. So I bit the bullet. It was hard, but I went back to work."[29]

I too "fell in love" with my first child. I too thought, "I'll just stay with her always and forever." I remember the glow well. It was Mary Pinchot Meyer who stopped me in my tracks: not with words but with a swift scornful glance as I was burbling along about not working in my studio while Alexandra was a baby, about how important it was to be with her.

The century-old government policy granting sectors of plains land—Montana, North Dakota, Texas—to farmers has been a failure. Farmers settled land but not for long. They shot the bison, plowed the grass under, planted but never harvested; rain scarcely fell. Nebraska saying: "God made this country right side up. Don't turn it over." Now the naked hills roll around the horizon. But history is rhythmic: a coalition of thirty Native American tribes are "bringing back the bison and, with them, elk, prairie dogs, ferrets, and hawks and, especially, the grass."[30]

The Penrose Mothers' Artist Colony in Wainscott, New York, is now in its second season as a free, part-time refuge for writers who are mothers. This July it has been used by five mothers and their eight children, none older than six. These mothers had hoped to write eight hours a day. They find that they can work only for five. But five hours is five hours.[31]

When Sam was about nine, he came home from school one day with the news that the world was running out of water and the air was becoming so polluted that soon we wouldn't be able to breathe. Human beings are natural problem-solvers. Tend to solve them one way or another.

Though only in the long run, I did not say—a run too long for our short lives. The other day the pharmacist failed to take notice of my insurance on a prescription that cost a flabbergasting seventy-two dollars and some cents; I paid three dollars. But sooner or later we the governed will be forced to eventually face the fact that citizens need legal protection, universal health protection. Had I been uninsured and poor I would have had to do without the medicine—the short run.

July 30

Late Sunday evening just before the light began to fade I reversed the way I've been shuffling toward a color on *Parva LIII*—reversed, inflected, and abruptly there it was. Categorical.

Michael Brenson and I spent the afternoon talking about David Smith.

I am sometimes asked to look back like this, sometimes asked and sometimes—often lately—do on my own. A continuum of time on which I slide easily, ratchet at a point, think or, if invited, talk, slide, ratchet . . .

Michael and I spoke of Clyfford Still too, whose paintings are being exhibited at the Hirshhorn Museum. A small retrospective: certain works, chords, audible space.

Still's quest, he said, was "self-discovery." He claimed that "art is the only aristocracy left where a man takes full responsibility." I remember David saying that too: "Artists are the only aristocrats."

Still despised the "art world." He left New York in 1961, moved to a little town in rural Maryland where he lived in "a white-columned house" next door to a funeral parlor until his death in 1980. He gave a number of his paintings to museums in San Francisco and Buffalo, but most remained in his

possession. His "will stipulated that his paintings be given to an urban museum that would guarantee the facilities he demanded, such as separate physical quarters and storage, and a reliable conservator and curator," plus other requirements.[32] He left no endowment to maintain his work.

It is ironic that no museum is dedicated to Clyfford Still's work, while Georgia O'Keeffe has one all her own.

Still: "I never wanted color to be color. I never wanted texture to be texture, or images to become shapes. I wanted them all to fuse into a living spirit."[33]

Amazing how self-centered a life can be. Finally, at the end of the day, mixed the color for *Parva LIII*.

Am content.

A just mind.

Formal but not conventional.

Conventional but not formal.

July 31

The last day of July. I am glad to see it go.

But before it does I must revisit Bryn Mawr.

Alastair seemed to find interesting the contrast between the gray gothic campus and his California Institute of Technology. He read some of his grandmother's youthful prose and stories and then went outside to look at the trees and plants, and, I guess, maybe to think. His experience is packed inside him so dense that it emits a low hum.

Margot, who went to Vassar, was interested in every detail of the campus. I could feel her imagining what it had been like to be a student here: her questions elicited, extrapolated, and appreciated. Her attention to the archive, both when she

examined it and when we discussed it with the special collections librarian, was utterly reassuring.

Alexandra was familiar with it all. After a visit to the archives some years ago, she had mentioned to me the existence of a 1948 to 1949 journal—February 5, 1948, to October 6, 1949. I found it on this visit and I read it in the sun this morning. The archivist had kindly copied it for me. I was shocked by the fact that I was thinking that way way back then.

I cannot bring myself to reread it right now. But in time I will, I also think, integrate it into this book that I seem to be writing without having intended to do so.

August 1

In 1951, Mary Orwen and I rented an unused horse stable in a mews near our houses in Georgetown. She painted on the second floor. I made sculptures of clay, cast cement, wire, and welded steel on the first. In 1952, she and her husband decided to adopt a child. The law in the district mandated that the mother remain at home with an adopted child for three months after the date of adoption. Mary asked me if I would teach in her stead, for the three months, a workshop in sculpture at the Mount Vernon Seminary for Girls.

I had never taught, had had only nine months of training in art, but Mary was persuasive—just teach the girls how to use clay, only three months, can't ask anyone else . . . So it was that she initiated the way in which I would earn my living for most of my life.

August 2

A perfect landfall: I opened my eyes at exactly the moment when night gives way to day.

Sam Truitt heads the "Poet's Sampler" in the *Boston Review:* the poet C. D. Wright writes on Sam's poetics. The page is partly sponsored by the May Swenson Poetry Award. Her wave poems evoke her person too—at Yaddo standing in front of West House, short, intent, compact, like a strong fish used to rough waters.

August 3

When we were children on Aunt Nancy's farm in Virginia, we seven cousins used in the summer to sleep on cots under the trees. Last night I sat looking out the double doors of my studio, watching fireflies and remembering those sultry southern nights.

The summer nights I was remembering—the soft, not-quite-dark air, the smells of earth and trees and sometimes skunks, the company of cousins, the safety of being one of many children, the sheer sensuous pleasure of sleeping under the stars—joined the night in the studio, bearing the linkage of years and years of nights, and swelled into a rare, entire happiness.

August 5

Rilke remarked that "we die our own deaths." Perhaps we recognize them first, just as we occasionally recognize our lives as belonging uniquely to us. Even in advance. I distinctly remember the strange preemptory feeling I had on that 1961 November

weekend in New York when my work abruptly focused and flooded my inner eye, as if I had *already made* it all. I saw then what I see now when I look back: a plain block of a life.

It would be easy for me just to exercise my faculties in the studio. I could run scarlet under *Nouvelle*. I can see it clearly; I feel the shock. But I am not going to, nor am I going to deviate from the yellow I have mixed for *Swannanoa,* except to inflect it slightly three times. And under *Parva LIII,* just enough to elevate it, will run a color almost, but not quite, invisible.

August 6

In one of the Norton Lectures he delivered at Harvard in 1967–68, Jorge Luis Borges speaks of the poet—the "maker"—and of the epic "wherein all the voices of mankind might be found—not only the lyric, the wistful, the melancholy, but also the voices of courage and of hope."[34]

The Iliad is "the story of a man, a hero, who is attacking a city he knows he will never conquer, who knows he will die before it falls; and the still more stirring tale of men defending a city whose doom is already known to them, a city that is already in flames."[35]

Just so we all. We get up in the morning and lie down at night knowing that we are not conquering, that our labor is disappearing down into the hole of time. Mute we move from day to day watching the cities of our hopes go out in sparks.

It is Homer who reveals and transforms and illuminates and inspires. It is poetry that forces us to know our own lives. We recognize ourselves writ large. We take heart.

August 7

The creamy roses that someone gave me last week have opened wide. All except one, which remains a tight spear of bud, furled against all giving or taking.

Are some people so closed, so close to despair that all their vitality goes into clutching for dear life its cold bone? If William Blake is right that "we are put on earth a little space, that we may learn to bear the beams of love," some of us may sadly not be able to.[36] Vitality underwrites objectivity, and it takes energy to be objective, particularly because seeing matters objectively reduces personal scale in the general order of things. It takes thought to acknowledge the actual existence of other people wholeheartedly. To wholeheartedly accept *another person,* their flavor, their will, their purpose, their sheer *differentness.*

And is intelligence not itself a form of vitality? Laughter too . . .

I like Blake's "bear." To accept being loved seems to me more difficult than loving, which is spontaneous in a lively heart. Being loved means being valued. Without being Uriah Heepish about it, I shrink from the idea of my own value—but that may be a form of conceit: being valued involves submission to evaluation.

Blake means divine "beams of love." Surely the divine is the final objectively, the final intelligence, its beams falling evenly, on all and everyone and forever and ever.

August 10

A hot spell.

Three sculptures creep along. I just came in from the studio and haven't even had breakfast—and don't particularly want it either.

Routine is a lifeline.

For the memory of another is like a ship which one
sees coming down a bay—the hull and the sails sepa-
rating from the distance and from the outlying islands
and capes—charged with freight and cutting open the
waves, addressing itself in increasingly clear outlines
to the impatient eyes on the waterfront; which, before
it reaches the shore, grows ghostly and sinks in the sea;
and one has to wait for the tides to cast on the beach,
fragment by fragment, the awaited cargo.[37]

August 12

"Typhoon weather" is what we would have called this in Japan:
the maids would have put moisture-absorptive packets in all
our shoes and looked to the *amado,* the iron "rain door" that
covered the windows.

My hair is lank and the bannisters under my hands were
damp when I went down to get coffee this morning. The vio-
lence of the lightning and thunder yesterday was unnerving.
We used to smile about a cousin of my mother's who repaired
to a closet with her pug dog when such storms struck.

When my children were young, I always made sure that I
stood strong in storms. But there were no children to protect
in this storm, and it stayed so long right over the house, shook
it so, pierced it so fiercely with lightning and so utterly over-
whelmed it with roll after roll after roll of thunder, that I felt a
whimper bubble in my throat.

It all went on for so long that I adjusted to it and began
to read (in the fading light, not venturing electricity) the

catalogue from the Portland Art Museum on its current exhibition: "Clement Greenberg: A Critic's Collection."

Self-centered, I looked first for *Bonne,* 1962, was glad to see it again. I last actually saw it in 1964 before we departed for Japan.

When Alastair was born, I went up to New York to help Alexandra and stayed in the Greenbergs' apartment a few blocks north of hers on Central Park West. Clem and Jenny were both away, so I was alone with part of this collection, and know many of the works.

Their photographs stirred memories, not so much of themselves but more of Clem's sitting among them, sitting forward, drink in one hand, cigarette in the other, alert as an eagle on a peak watching the plain below, ready to swoop.

Anthony Caro writes in this catalogue of the value of Clem's comments in the studio. I don't remember comments; I remember the value of his appreciation, his vivid, quick, utterly present grasp of my work, his openness to it—without let or hindrance. The sheer encouragement of it: irreplaceable.

And I remember what good company he was. There was no subject on earth or in heaven that Clem didn't enjoy discussing. I wish that we were once again lunching at Prunier's in the Imperial Hotel in Tokyo: vodka martinis and platters of oysters flat in their shells on top of cracked ice. Now what I would like to discuss is the surprise of aging. Clem was brave. He understood how raw it is to be alive, yet tried never to flinch.

"You can no more choose whether or not to like a work of art than you can choose to have sugar taste sweet or lemons taste sour."

"A precious freedom lies in the very involuntariness of aesthetic judging: the freedom to be surprised, taken aback, have your expectations confounded, the freedom to be inconsistent and to like anything in art as long as it is good—the freedom,

in short, to let art stay open. [. . .] You relish your helplessness in the matter, you relish the fact that in art things happen of their own accord and not yours, that you have to like things you don't want to like, and dislike things that you do want to like. You acquire an appetite not just for the disconcerting but for the state of being disconcerted."[38]

I don't, after all, need to go back to Prunier's. One of the arts of aging is to "acquire an appetite not just for the disconcerting but for the state of being disconcerted."

August 14

Carmen Angleton, my friend James Jesus Angleton's sister, died five days ago, in Rome where she had lived her life. She developed into the Titian portrait that her mien promised when we were at Bryn Mawr. Our lives may simply serve to render visible what we already are when born, or were born on purpose to show forth.

Like the multitude of fireflies I watched the other evening from my studio door, my generation flickered in, and out.

August 15

I went yesterday for a day's visit to Mary's household in Annapolis. Charlie, twenty-one, is back from his summer in Paris; Rosie is still at "home camp"; Julia was helping Mary's babysitter to paint her new apartment; Henry is now a medieval knight equipped with a helmet, sword, and cape, and gallops around on a stick horse with a fierce brown mane. The baby Isabelle's hug, her short firm arms all the way around my neck

and her bright curls against my cheek, was at once infuriatingly heartwarming and heartbreaking.

I am amazed by all my grandchildren. Their very existence is astounding—so objective the independence of human continuity. My love for them is uniformly deepened by my recognition that I have no hope of seeing their future lives in the far future.

I drove home feeling vaguely disconcerted, ate a nothing supper and went to bed early. I remember thinking, "It's all too much," just before I finally went to sleep, but I was in no way prepared for the devastation of the long night's dream from which I have just awakened, desolate.

Desolate. A helpless onlooker, I watched an ever-more-numerous procession of determined, declarative, arrogant, and powerful people overrun my house, then my garden, and finally my studio. All sorts of people with all sorts of purposes, all intent, all rushing, all moving through and on, taking everything with them: at one point I decided it was hopeless to protest. I sat down in the studio, on the little wooden "ice-cream chair" left over from Walter Hopps's 1928 Calvert Street Corcoran Gallery Workshop, my back to the garden to the south (even the young Wye Oak had been uprooted), my face north into the bare branches of the tree beyond the broad high windows, and I thought, "When they go, I will just make it all over again." In the clamor, people came and thrust their faces into my face, and asked me where certain papers were, how could I prove this, what record did I have of that? I answered politely and kept my hands quiet in my lap. On and on, and then as the people began to thin out, carrying things off, my eye dropped and I saw that the floor of the studio had become freshly waxed hardwood, new and shining—my cement floor, spotted all over with paint drops from all the work I had done there, had been obliterated, replaced. And at that moment, a

particularly large person punched into me and gave me to understand that the land on which my house and garden and studio were built did not belong to me and had never belonged to me. The knowledge that I could not ever remake the life I had lived on this land struck into my bones—and I woke up.

Just so. I dreamt my own death. All will be obliterated. Certainly my work—by the time I made my way through the noisy crowd to the studio it was already empty. And all the trivial contrivances devised to make my life viable, maybe even useful.

When it does come, my death will be negotiated by my family, and my life not so *obvious* a failure. But the fact remains.

It has been a hard day to live: one foot in front of the other. I have made sure to cook a proper supper, and will be sure to eat it now that I am in from the studio. The floor is itself.

Harvest Shade is almost finished. *Parva LIV* and *LV* are steady as they go, and so is *Nouvelle*.

August 16

Physicists apparently are discovering that what they had assumed to be immutable laws—the speed of light—may be changing, very slowly, as the universe ages.[39]

The laws governing the initiation of human individuals may also operate in a timeframe of change. Both egg and sperm are living matter when they meet, but an embryo results from this meeting only if, about fourteen days later, certain specific genes are "switched on" in what embryologists call the "primitive streak," "sending out signals" that indicate changes leading to the development of the "polarity and structure" characteristic of an embryo.[40]

So the force that may actually initiate the development of a human being is independent of both egg and sperm meeting.

So too, the force that initiates and animates a human life eludes scientific nomenclature—the primitive streak!— remains as mysterious as it is pragmatic.

And there is a distinct period of time between the union of egg and sperm and this initiation. During this period the stem cells produced by this meeting in no way constitute *human* life. So these cells are, from every doctrinal point of view, morally available for the research that promises certain regenerative cures.

August 17

As twilight overtook the afternoon yesterday, James Meyer (who will be coming here on September seventh or eighth to talk over an article he is writing for *Artforum*) and I tried to isolate and characterize the "taste" of egoism. Metallic, James said. Not copper though, I said. Some kind of metal, we agreed. And sweet, I added, sickening sweet on the tongue and in the throat.

Inevitable, egoism, when work goes from being private to being public.

Or, I have found, I said, when I am moved to abandon and jettison the balanced, reasonable perspective of self-respect for the role of An Artist, in capitals, when I feel a certain righteousness in what I present to myself as "standing up for my rights"—by extrapolation for the rights of artists as a genre.

Every single instance of disharmony in my experience had been initiated and egged on by egoism. Not that other people

haven't contributed to the disharmony—egoism is catching, and perhaps I have sometimes caught it from others.

This is not a matter of guilt, James and I agreed. Rather a matter of detecting the first metallic sweetness on the tongue. Paying attention to it immediately. Turning on it a beam of intelligence until it dissolves. A difficult thing to do, as one of the facets of egoism is a fat sense of self-satisfaction, hard to relinquish.

There's evident worth in doing this, but the motivation is the avoidance of a feeling so intensely disagreeable that it constitutes a personal evil.

August 18

The thrust into maturity is through the eye of an iron needle. Antediluvians, beleaguered in middle-age, are forced to decide: either to clarify, acknowledge, and accept the circumstances of their lives as the results of their own actions and to shoulder the ensuing responsibilities, or to substitute lullaby for struggle, to use their imagination to construct a self-protective rationalization within the beguiling context of which they listen to their own sirens.

Some constructions are necessary: I do not have the courage to face the raw facts of my life every day and all the time. Odysseus asked his shipmates to bind him to the ship's mast so he could hear the sirens in safety. But I try to *remember* that they are constructions. The memory of how much you owe the tale of your life to your own constructions may in time thin out, evaporate, and your conscience become torpid.

August 21

Even though I cannot see well at night—grass is especially scary, it looks like some kind of maelstrom swirling down into undifferentiated darkness—my mind more and more precedes my body. Stand up, I think, and then have to wait for my muscles to do their duty, even though . . . even though . . . I am curiously happy.

My work goes more easily than I do. When I was in my fifties, I used to keep running notes on coats of paint, records of vertical-horizontal and numbers. Now every sculpture keeps pace with me, or I with it, in a new slow time. We keep each other better company than ever before.

August 22

Alastair tells me to deadhead the purple buddleia bush he gave me last year, and, next spring, to cut it back even with its new shoots when they are about ten inches high. The lemon mint he also gave me he now considers a weed, but agrees that it will be pretty running wild around and under the bird bath I plan to put on top of the stump of the crabapple tree that lived to be over thirty, though twisted in its last years by an ice storm that broke its branches some eight years ago.

Charlie and I had lunch yesterday on a deck overlooking the Annapolis Harbor, then got ice cream cones and sat on the dock watching the boats. He told me about his summer of working at the *International Herald Tribune* in Paris, of his little apartment on a street parallel with the Quai Voltaire on the Left Bank, of how he gradually became familiar with the rhythm of the city's daily life and was finally absorbed into it. Events may be anecdotal but I love thinking them over.

The thoughtless pleasure of being with the person you love. My love for my family, just being alive and beside them, has breadth, width, and depth, weight, as if it were a sculpture. Way down under is a fearsome line that never quite fades out: fate, Greek fate—the Eumenides, hubris.

August 25

In the early 1980s, museums began to offer tapes of educational comments to which people could listen while walking through an exhibition. In theory an exciting idea that could initiate provocative interaction between art and the public, but in practice, I think, numbing: art filters through authority and emerges in the form of information requiring little more attention than a weather report. People listen to their earphones, their eyes in neutral, and jerk like automata from highspot to highspot. The moving eye does not see—sight depends on foveal vision or focus—so the nuances of an exhibition must be lost if explained this way, on a level scarcely more taxing than a visit to a theme park.

Another step in this interface of art and public: museums are showing video games made by artists. One of these young artists is Miltos Manetas: "I discovered games, searching for a strong subject to represent. In the time of Goya, this was the life of the rich and of the poor; in the time of Cezanne it was nature; in Andy Warhol's time it was movie stars and famous people. But for us, what really matters are pieces of hardware and of digital personae. I also paint computer and video game gear, because it is original material."

He goes on, "Nobody has made any art with such stuff before."[41]

As soon as I get the opportunity, I will go and look for myself at this new work.

Proust situates his narrator in time by the invention of the telephone and motorcar, and the narrator's attitude to these "pieces of hardware" is to use them to broaden his range of experience. Just so Manetas: mechanical artifacts are apparently as potentially enlightening to him as Goya's anguished "rich and poor" or Cezanne's lawful landscapes.

On its face, I find this idea meager, but I was born in 1921—automobiles were called "motorcars," our telephone number in Easton was twenty-nine, and the operator knew where people were: "Mrs. So-and-so is at Mrs. So-and-so's, or, out of town until Tuesday, or . . ."

August 29

Sam is here for a few days. He has his computer and has set himself at my desk. He works there, I work in the studio.

His presence makes the air nourishing, like that of a greenhouse in which the plants flourish.

September 1

The cliché that we receive in our lifetimes everything that we have honestly and truly wanted is certainly true in my case, except—a looming except—for being able to make people I have loved and love happy, for happiness depending on others. Like a fiddle fern (I watched uncurl its fronds in our garden in Japan on a sunny spring afternoon two months before we returned to the United States), my life seems in retrospect

simply to have unfurled into what it already potentially was.

What I used to think of as inexplicable coincidences I have to come to regard as points at which the vast warp and woof of cause and effect briefly open to sight.

And every now and then a skein of this meaning is gathered as if into a net and flung free so that I can see that it is a whole within a larger whole as well as whole in itself.

A clean line. I made *Two* in the Twining Court studio. Cord bought it about a month later. He and Mary lived at 1523 Thirty-Fourth Street; *Two* was placed in their front hall. It remained there until yesterday. *Two* is now on its way into the Yale Art Gallery, a gift from Quentin and Mark Meyer in memory of their father and his twin brother who was killed in the Pacific in World War II.

Its history is ideal: a provenance of affection as well as of place, and one hundred dollars the only money anywhere near it.

A deeply satisfactory aspect of this transaction is that only a hundred dollars in money was involved. Adriaen Brouwer, the Flemish painter (1605–1638), was handed two hundred guilders for a painting. One guilder was the common wage for a day. "When he got home, he poured the money on his bed and rolled among the silver pieces. Then [. . .] he spent most of it overnight and felt relieved that he had 'rid himself of all that ballast.'"[42]

Money and art are poor bedfellows.

September 2

Prayer is lightness of heart.
The answer to prayer is lightness of heart.
Lightness of heart is uncommon in prayer.

September 3

If all has gone as scheduled, Alexandra and Jerry have lifted off from Istanbul into the air. They are due to land at JFK (how we take those initials for granted, how bare they are of Jack Kennedy's endearing vitality) at 3:55 this afternoon.

I am excited. Today I start to finish the work in the studio, start to prepare for the work I plan to do at Yaddo—I leave in three weeks. I am already winding around the roads I first put foot on almost forty years ago, my eyes soaring up to circle the trees I will watch each day descend toward winter.

September 5

I answered the telephone and heard Kay's voice say "Anne," and for a wild millisecond spun out into belief that she was alive after all, so exact was her affectionate rumble.

September 6

Delightful: I am sitting up in bed warmly wrapped, with my favorite soft yellow blanket over me and my Italian coffee mug full of fresh hot coffee by my side. The sun has not quite risen. Vermeer is perhaps best at getting the pellucid air that envelops me for just this moment, remote from the coming day.

September 7

A traveler approaches a crossroads. He knows that one fork leads to the town that is his destination. He also knows that he is in a land inhabited by two tribes, one that always tells the truth and one that always lies. When he reaches the crossroads he finds one member of each tribe standing at the fork, but no tribal mark distinguishes liar from truth-teller. The traveler points to one road and asks one man, "If I were to ask this other man whether this is the road to town, what would he say?"

The traveler reaches the town because he could ask a pragmatic question. More generally, truth can only be Dryden's "beast in view."

Epimenides, the Cretan: "All Cretans are liars." Epimenides, Megarian, sixth century BC philosopher, invented the paradox known as the Cretan liar: "If he is telling the truth, he is lying; and if he is lying he is also telling the truth."

September 8

J. Meyer: The Minimalist artists derived a language and syntax that stripped art of content. Feminist artists used this language and syntax to express the content of feminism, turned the minimalist guns vs. the minimalists.

You were about expressing your own content—content that emerged into your work in forms that only later were defined as Minimalist. Thus were you in a formal sense a forerunner of the feminists?

On that November weekend, did the *pressure* of profound hopelessness in your marriage, the *cagedness* of it, provide

the force that overturned the form of your life and work, and poured it into a new form created by this very content itself?

NOTES

Dammed-up force of individuality.

Had submerged myself in James's life, in patterns I had been expecting—and expected—to fill: daughter, wife, mother.

Tubes tied after Sam's birth November 12, 1960.

Baby not really born for one year.

Had conformed on outside.

Gone own way in very narrow channel.

Divisadero house—was the woman in the attic who was silent.

Who was unheard.

Who was obedient.

Who was reasonably compliant.

Revolted against pattern but always in a circumspect, secret, sly way.

Furtive.

Unleashed.

I could have considered my life as a series of events. I have lived with ambitious people, have affinity with them. I remember sitting at the delicate inlaid French desk that my mother designated as all mine to do my homework on, and deciding to do all my work perfectly, the words clearly written, the arithmetic problems correctly completed, compact units in tidy, well-spaced rows. I have lived with involved people too, since 1947, mostly in Washington, so placed by James that I have observed and sometimes been ancillary to what turned out to be history, in a surprising and fascinating way.

A linear account of my life might be a rollicking good yarn, a provocative example of how preemptory *fate* can be.

But events are anecdotal. A life is not. I hear mine: an unwinding musical phrase in which every note evolves into every chord and every chord echoes.

September 10

Johannes Vermeer was baptized in October 1632, betrothed in April 1653, and buried on December 15, 1675. He lived in Delft, an elegant, small city on the river Schie, circumscribed by walls and crisscrossed in the Dutch way by canals.

One day when he was twenty-eight, Vermeer climbed the stairs of a house that stood across the harbor, south of the Schiedam and the Rotterdam Gates. From this high viewpoint, looking over the harbor north to the two gates and beyond to the city, he painted *View of Delft*. So perfect a painting that it defines perfection.

Proust's "Little patch of yellow wall, with a sloping roof" is in this painting. His novelist, Bergotte, dies while gazing at it. "He fixed his eyes [...] upon the precious little patch of wall. 'That is how I ought to have written,' he said. 'My last books are too dry, I ought to have gone over them with several coats of paint, made my language exquisite in itself, like this little patch of yellow wall.'"[43]

By 1675, Holland was ravaged by war with France. Stricken by drought during the summer and autumn, the country was further afflicted by a flu-like plague. Vermeer "collapsed" in December. His wife, Catharina, "said that the effect of being unable to trade, being so burdened with children and being without resources had caused her husband to lapse into 'decay and decadence [...] as if he had fallen into a frenzy, in a day and a half he had gone from being healthy to being dead.'"[44]

The Chamber of Charity noted: *Niet te halen* (nothing to be got). He left behind him ten children. When he was buried the family grave was so full that one of his children, an infant who had been buried two and half years earlier, was removed and his tiny corpse finally came to rest on top of his father's.

Marcel Proust: "Our experiments in spiritualism prove no more than the dogmas of religion that the soul survives death. All that we can say is that everything is arranged in this life as though we entered it carrying the burden of obligations contracted in a former life; there is no reason inherent in the conditions of life on this earth that can make us consider ourselves obliged to do good, to be fastidious, to be polite even, nor make the talented artist consider himself obliged to begin over again a score of times a piece of work the admiration aroused by which will matter little to his body devoured by worms, like the patch of yellow wall painted with so much knowledge and skill by an artist who must forever remain unknown and is barely identified under the name of Vermeer."[45]

September 11

Terrorists hijacked four airliners full of passengers at three airports this morning. Ridden as missiles, two flew into and destroyed the Twin Towers of the World Trade Center in New York. The third flew into the Pentagon here in Washington. The fourth, thought to be on its way to another attack in Washington, crashed in Pennsylvania. In response, all commercial airliners are grounded, all government buildings, including the White House, evacuated. A state of emergency has been declared in the District, Maryland, and Virginia.

I hear the beat of helicopters and the high pitch of military aircraft. Otherwise, silence.

September 13

I hear this high pitch, multiplied, in the early morning darkness and feel the same throb I felt under my rib cage all through World War II. I cannot draw a deep, free breath, and take in shallow draughts the suffering of the thousands of people who two days ago endured terror and flame. Their last minutes on earth.

Caught in images as well as in death. Actuality mocks art. A man, clearly dressed for a day of work in a proper dark suit and white shirt and tie and dark socks and shoes is upended against the formal steel lines of a World Trade Center tower. He is plummeting hideously to his death—with time to think as he goes. He looks like the figures that Robert Longo drew in the early 1980s, figures caught and spilled, as they jump in desperation from the roofs into the sky above New York. Longo's content is irony. This man is falling in sheer, honest agony.

Recent apocalyptic art is lame. These *real* airplanes launched straight into the towers at full throttle. Great brilliant bouquets of flames blossomed, and the towers imploded deliberately as if mocking slow-motion film. Inside the airplanes, *real* people who were simply going about their lives were strapped in their seats, entrapped by madness, forced to endure and die with their eyes open on a sunny morning.

The World Trade Center towers were as proud against the sky as the concept for which they stood—a planet animated by vigorous and peaceable commerce.

Sam, who lives a few blocks north, walked down to do what he could to help. There he got through to me on his cell phone

to say that he was all right. I heard the sirens around him. "We are diminished," he said, "the city is diminished." If our cities are disemboweled our culture will perish: a civilization's growth demands urban centers, places where currents of thought crisscross so that new ideas can emerge. Places like the World Trade Center.

Pax Americana: we had a good run. War braces on the tongue. We could join Rwanda. Peace depends on its eradication by a joint effort of all nations. Peace depends on the rule of law. I have no hope that I will live to its global establishment. My uneasiness on the gray day of George W. Bush's inauguration foretold his headlong rush to lead the nation into war. Bush: opportunity lost.

The attack on the eleventh was an act of terrorism, criminal, hence most wisely referred to the international legal system. Not, like the attack on Pearl Harbor to which it is fatuously being compared, an act of war. I have the terrible feeling that a war is being *invented* here, as if to act out a boyish fantasy of hero-hood.

Plutarch believed that "good fortune will elevate even petty minds." Sometimes. Perhaps.

Planetization set back maybe two generations—greatest failure of leadership I can think of.[46] Same in a life: you don't see what you see until you see it. Karma has a timing systems analysis: *This* has to happen before *that* can happen.

The sun has come up. The day stretches ahead in unspeakable sadness.

September 16

First I stopped writing, then talking. All, all cliché. Patriotism—
honest patriotism—is exploding around us into jingoism: red,
white, and blue American flags flap in the air, which now smells
of jet fuel trails left behind by the F-16s ceaselessly circling
Washington. Red, white, and blue ribbon rosettes ride like
burst hearts on the chests of loyal citizens. Though meeting
in an ordinary official room at Camp David, the president and
all his advisors sit around a huge rectangular table clad in
heavy army-color jackets as if meeting on a battlefield. "We
the People" are drawing together into a tide racing ever more
rapidly toward war. I have heard only *one* commentator, Katrina
vanden Heuvel, speak of the necessity to understand *why* the
United States is being attacked. I feel the way I felt during
World War II, as if I were a sad shadow in a crowd of unsane
people gesticulating.

It seems so clear to me that means determine ends, that
force invariably provokes force. I figured this out for myself
during World War II when I was in my twenties. Mainly because
of experience with the rapid turnaround of sailors who had
been stricken with what was then called "battle fatigue,"
flown home to the Chelsea Naval Hospital, briefly treated,
and flown back to the war. Men we in the psychiatric ward at
Massachusetts General Hospital used as subjects in an exper-
iment to find out what could be done to offset the effects of
anoxia in fliers. I saw these men with my own eyes, men com-
pelled to kill and to be killed—young men, eighteen, nineteen,
twenty, twenty-one . . . To kill is worse. If killed, one is beyond
memory, but the act of killing leaves one marked forever.

I have always in the back of my mind known that there
would be a World War III, that my children and grandchildren

would have to face in their time what my generation did in ours; something cyclical seems to roll around to this terrible spasm. Last night just before I turned out the light, I looked at the shelves opposite my bed, at a box that Alexandra painted—a spouting pink whale on a deep blue sea on top, and on the inside a large red heart pulsing on our brown house with its apple tree beside it: hanging on its branches are three healthy red apples. The shelves are jammed: books on classical history, a Tiffany plate (white lotus flowers on pure blue and green), another plate from Mary's godfather with the date and time of her birth on it, a flowered Iznik tile Alexandra brought me from Turkey, and a flotilla of pictures: a delicate miniature of my mother's great-aunt Louise Baker, a snapshot of Sammy at two with James's handwriting on the back, another of Charlie at three striding up a dirt road in Vermont, another of Julia stretched out on the sand with her father and sister and brother behind her on the edge of a sunny ocean . . . *life*.

September 17

I was stretched out on my bed in the gloaming when Daniel Jones telephoned. He is the only person I have encountered since the eleventh who addresses the national situation as flatly as I do. We will as best we can stand in place and face forward. We met at the end of World War II when Danny returned to Harvard after five years as a naval officer and I was working at Massachusetts General Hospital in the psychiatric lab by day and as a Red Cross nurse's aide by night. Neither of us expects to survive this war. We agreed that we had loved each other "all my life."

September 18

Mary took me to the hospital at 8:30 a.m. yesterday. She waited for me while I was in in-and-out surgery, so I had the comforting knowledge that she was nearby.

Another patient was not so cherished. He was admitted at the same time I was. His wife dropped him off with the words, "I have a luncheon at 12:30 and will pick you up at 2:30." "Could you possibly leave your lunch a little early?" No she couldn't, and she walked out of the hospital without looking back.

September 19

Fifty-four years ago today James and I were married. Few there that afternoon of sublime happiness are alive now—I can think of only three. In a bubble of memory James and I shine side by side. We do not yet know that it is change that is the pith of growth, nor that we would change at different rates in different directions.

Their backs to unbearable flames, a man and woman were seen to have joined hands before jumping off one of the World Trade towers. My hand in James's and his in mine . . .

September 21

Of course I do not know what will happen as this nation embarks once again on a course of violence. But I do know what I am going to do, which is to hew to my own line. I was pleased to read that Richard Serra and his wife, Clara Weyergraf-Serra, did not leave Tribeca where Serra has lived

since 1967. "I live here," Serra said. "You do what you do. [. . .] You try to assume a normal life, that you can work yourself back into."[47]

Autumn

September 25

Yaddo: Still. Dark, steady slow rain. I am in West House, rooms one and two, in what I always think of as Malcolm Cowley's rooms: bedroom with two beds, study with sturdy desk lit by two lamps, commodious bathroom. Malcolm walked with a cane on his last visit here, years ago. I walk with a cane.

Drove up all day yesterday in my car. I don't think I've forgotten anything essential. My typewriter is in Pigeon West, plugged in and alive. Only one other guest so far: Jonathan is a writer, a brand new member of the Corporation of Yaddo. Sonny Ovitt, whom I hired in 1984—he told me he could write his name with the backhoe—joined us at dinner in the library.

When I turned in to sleep, I felt the familiar, light, warm pleasure of West House enfold me.

September 26

Order. Like an amoeba, I have pushed out pseudopodia here and pulled them in there, and now fit and fill my rooms and my studio.

One of the three horses of the troika I plan to drive ahead here is the transfer of this writing into a typed manuscript. Late yesterday I started and was startled: the major effort and the major aim of my life now is precisely to pursue the dissipation of "I" that was making me uneasy last January.

It will be a discipline to type up these notebooks exactly as I wrote them—like H. G. Wells's description of Henry James's writing, which he said was like "watching a hippopotamus pick up a pea."

One guest cancelled a visit, and others deferred and are coming in late. One is from Cuba, all the rest all from New York. The New Yorkers are shocked. Their eyes look white. They could be my children, even grandchildren.

Jonathan, the appointed assistant, has simply decided that I should be "walked home" after dinner every night, and that's the way it is. A kindly arrangement—I just say thank you. John, a sculptor, thirty, is with me in West House and has the Greenhouse Studio and the Welder's Studio that George Rickey gave Yaddo in 1984, that he and I planned together and I saw well along while I was acting director that year. I wish I could tell George how things turned out, but I hear that age has strangled him.

September 27

The lakes are silting up. The blue heron have apparently departed, the ducks also. The waters are here and there so shallow that they are only a realm of weeds growing toward the sun.

September 29

We are reached here by way of messages the office leaves for us on the mail table in the library, where we have breakfast and dinner. Last night I found a pink slip: Maida has died. In Maine, near her dear Cranberry Island, encircled by her three children.

In America we rarely die where we were born. Maida was born in Kalamazoo, Michigan; married a poet. Robert founded the Institute of Contemporary Arts in Washington. Its program was based on that of Black Mountain College: all the arts under

one roof. I studied sculpture there for nine months in 1949—my only formal training. One of the arts was ceramics; Robert invited Bernard Leach to come from England to visit, the first of the artists the Institute sponsored. Others included Dylan Thomas, Elizabeth Bowen, Isamu Noguchi, Naum Gabo, Hans Richter, Rufino Tamayo, Marcel Duchamp, Herbert Read . . . Virtually every interesting artist in the world. After the lectures we talked.

The touch of these artists was brief but intimate. It was Marcel Duchamp who, in a night of conversation, suggested to me that I might not exist—as I am finding out now that I indeed do not.

Robert died some years ago, a long way from Michigan in Myrtle Beach, South Carolina. Maida and I have for a while met only occasionally, but I miss knowing that she is breathing. My friends are flickering out. Carmen died in Rome last month. She was born in Boise, Idaho, and is being buried there today beside her two brothers. No wonder I am making very plain pencil drawings with not many lines and almost no paint.

But yesterday I saw a blue heron, wide-winged, land on one of the lakes. And two ducks too, swimming in their complacent way, in accord and as if keeping house together. I see that the lakes are on their way, in a hundred years or so, to being meadows.

October 1

I am told no: plans are in hand to dredge the lakes.

Structural changes in the position of branches in the woods do not change the effect of their color. But even subtle changes in color affect the structure of the forest.

October 2

I am in my studio, all the lights on, coffee at hand. Abiding habits. I woke up, got dressed, and tiptoed out of West House. I awoke alone, and for the moment content.

Just for the moment. Stories of lives cut off by the terrorist attacks continue to roll out every day. "Loved to cook . . ." "Planned to build his dream house . . ." "Took tender care of his children aged two and four . . ." "Four months pregnant with her first baby . . ." "Called his wife on his cell phone to tell her that he loved her, that in all and everything she decided for herself and their children in the future he was completely behind her . . ."

A guest from Chicago told me last night that a relative expert in anti-terrorist activity telephoned her before she came here, warned her not to fly out of any major airport. "But I have to live my life," she said. And flew.

New York and Washington are "ground zero," these experts say. One: "People living in New York or Washington should move out instantly." To meet in Samara the death avoided in Damascus? In Elmira the death avoided in New York, in Charlottesville that evaded in Washington?

A young artist questioned his life. What did art matter now? But I am staying my mind on Tolstoy's *Resurrection*. On Titian's *Flaying of Marsyas*. On Rembrandt's indomitable eyes. On Vermeer's *View of Delft* particularly: one bright morning in 1654, Delft's municipal munitions cache blew up, in an instant destroying almost a quarter of its inhabitants; six years later Vermeer painted the city, serene under a bright sky.

Like all attentive lives, the life of an artist *is* worth living. I think that for me it started with specific things in the world around me that caught me when I was very young and have held me ever since.

My sense is that the initial source was inside me when I got caught, that I looked "out" and saw something that matched what I already knew to be true, so precious that I hung on to its equivalent and thus undertook an obsessive life. What is virtually undiscernible: the *edge* of discernment, as invisible as visible. On this edge, very close differences: in proportions, in the values, hues, and depths of what is called color. It is not normal, but I feel these differences to be life or death.

I have grown with time in their pursuit and am nervous right now because I am continuing on my own nerve, but making things that don't look to me as if I am. The sculptures I made in the last year *do* look like my work, and *Swannanoa,* left under-coated in my studio, does in prospect; it is coming into its own even as I write. All I can do, all I know how to do, is to keep on and trust as I always have that something in me knows what I am doing.

Restless. Restless. Restless.

October 6

I have been calling the dark paintings I have been making since 1999—Mary says they look like the scrapings of Beowulf's fingernails—*Farther,* but now I see that I am making *Nearer*.[48]

A fact emerged: these works are paired. I've been making two at a time without thinking. I suddenly see why. Spaced out two by two, they take place. Something hard-coiled in me uncoiled to see it. Offspring of the original 1962 *Two,* now at Yale, but more than that, much more—*origins*. I feel them that way.

Along with *Nearer* I am making *Strait,* seven-by-ten-inch-thick Arches cold-pressed paper, rough: light pencil lines,

within them strict rectangles painted. *Nearer* is ALL black. *Strait* virtually white. *NO color.*

The paint on *Nearer* and *Strait* is put on the same way, and a new way for me. My hand runs free and sets the paint free. I have never in my whole life been able to do this before.

Two horses in my troika are running straight ahead of me. The third is this writing. It's hard right now to take a single life seriously. Existential: what I have done I am accustomed to being responsible to. Perhaps today, yes today, I will put one heavy foot in front of another.

In between, lying on the bed in the studio, I read Tolstoy's *Resurrection*.

October 8

This nation, my own, has started bombing Afghanistan. I am sick at heart. We have not evolved a civil society. We are clever but we are not good. President Bush and his advisors have missed, and do not seem to recognize that they have missed, the best opportunity in this century to declare sovereignty of international law on our planet. Much courage, ingenuity, and endurance, on both sides of this conflict, will instead support the punitive law of tooth and claw.

Both my father's and my mother's forebears revolted against the crown of England to establish the independence of this country. Ever since I was a child I have thought of myself as another in a stout line of idealists, and entertained the idea that the concepts on which this union was founded would spread to foster the "right to the pursuit of happiness" for all people everywhere. Instead, Americans, way up high in the sky, skim very fast over men and women and children way down

below them, and kill them. And, a final irony, blackmail their victims by raining on them food as well.

October 10

Nearer is growing. I am now stockpiling.

I see that in this work I am *setting the edge free:* I fray the edges of the canvas and then leave them alone so that they open the work out into the world and at the same time reveal the canvas-ness of it. And then I set the paint free—my hand flies.

Before this I layered paint because I put it in the service of color. Now I am putting it in the service of itself.

I used myself to be in the service of concept. I'm not sure what the concept of these *Nearer* works is. But I know how to make them now and will find out in time.

October 11

I've been thinking about my revolutionary forebears. John Milton was born in 1608, when they were living in the fen country around Norfolk. He died in 1674—one year before Vermeer, who was born in 1632—when they landed in America. Protestants hounded out of England by religious persecution, they may have, perhaps even must have, been familiar with Milton. And by the time that Vermeer painted *View of Delft* they were Boston citizens. The earliest, Robert Williams, was the town bell ringer—I guess cried out that all was well during the night. And was one of ten men in Boston to have himself and his family vaccinated against small-pox. He is buried in the Old Granary off the Common, but I have never been able to find his grave.

Another forebear, on my father's side, was Captain John Pulling, vestryman of Old North Church, one of two men who stood guarding a third who put out a large light in the church tower to signal to Paul Revere that the British were coming by land: "One if by land, two if by sea." Captain Pulling's portrait (his head is shaped like my sister Harriet's) hangs in my dining room.

I grew up hearing occasional stories about these people, and absorbed the idea that no matter how inconvenient, a personal conscience was what should guide behavior. But I grew into a more unconventional, defiant independence. A photograph of me at about ten shows a strong-trunked girl in a Dutch costume standing up very straight. It would be a nice little picture but is not: the girl's head is over-high, her face is tight, unsmiling, and stiff, as if she were withstanding, withholding herself.

I remember that at some point, very young, I left my family behind and took off by myself to see what I could see and what was what. Not *not* loving my family, but a peremptory sense of myself as separate. Parents, obviously, can have special instincts about their children, and I think mine did. They gave me their trust and set me free—as I am doing with edge and paint now that I think about it. And color in my sculptures.

October 12

Mary, my dear friend, was murdered thirty-seven years ago today. We who loved her miss her—now and then we ask one another how things would be if she were still alive, and cannot even guess with any conviction of accuracy; Mary's ways were her own. One afternoon she got locked out of her house in Georgetown; she drove to our house and picked up Alexandra

and her goddaughter, Mary, who was four, showed Mary a tiny window into the basement and helped her to push through it so she went upstairs to open the front door. Alexandra and Mary were jumping with delight when later they told me this tale. Mary died the following year. She left her goddaughter two tiny salt spoons, the beginning of a collection she intended to make for her, and the experience of solving a problem with ingenuity and energy.

October 13

Two weeks from today, Saturday, I will pack my car. Sam and I will drive south on Monday. He has had two visits to Yaddo, and we plan to walk around the lakes together on Sunday afternoon.

Perhaps my last circle. I have the impression that I may not visit Yaddo again. Because I am a member of the corporation I am welcome whenever I ask to come, but I appreciate the right too much to exercise it too frequently, in deference to younger artists. It isn't fair.

Not all the time but often enough I have to use a cane to walk and a magnifying glass to see.

October 14

I run into a small dear chunky boy of about three and his nurse, a kindly woman whom I know, on the corner of Dover and South Street in Easton, Maryland, where I grew up, the corner where Miss Riley's ice cream store used to be. The child brushes up against my legs. He feels sad and lonely and wants to go home with me and play with my children in our cheery household.

His face is red and he might cry but doesn't. My first instinct is to pick him up and take him home, but then I remember that I have things to do that must be done and that this is a rackety afternoon at home with my children and their friends running all over. The little boy is younger; if I take him home, I will have to entertain him myself. First I say yes, but then I exchange glances with his competent nurse and say, "Some other time." I know some other time has no meaning for this small boy: I hear him thinking "She doesn't want me" even as he walks off down Dover Street, slightly ahead of his nurse, alone.

I wake up. I am stricken. I try to go back there and make a change, pick the child up and hug him warm and take him home, but I cannot get back.

How many, many times I have behaved this way: other things being equal (the boy's nurse I know to be devoted) I go my own way.

I remember too that the other afternoon I swatted away a deer fly that bit me on the top of my head (they like hair) while I stood on the slope above the western-most lake. The next day another deer fly buzzed over the sink in my studio: I had a brush heavy with black paint in my hand and instantly painted it dead.

October 15

Yesterday Jem Cohen and I drove out into the country to buy apples. In his old, very American, strong, stout, roomy car; its weighty doors shut with a definitive clunk. My little Honda is, though tactful, tinny. The apple orchards cover an open ridge overlooking in the blue distance a range of Vermont mountains running north-south the whole length of the eastern horizon.

We were happy to stretch our eyes. Happy to be in a crowd of Sunday people drinking hot cider and eating hot cider doughnuts, happy to see children in arms and children hopping along holding their parents' hands, happy to buy for our friends boxes of Macoun apples—local, dark red with pure-white insides. Happy too to talk things over together.

On the way home we stopped at a weather-beaten antique store. Jem picked out some vintage postcards. I, three delicate silver teaspoons for my three granddaughters, a funny-looking woven straw thing that the owner simply gave me, a pale blue-and-white Chinese candlestick for Mary (who likes odd ones for her dinner table), and a beat-up copy of *Smoky* by Will James for Henry, who will be five on November eleventh. Smoky's first sentence is, "It seemed like Mother Nature was sure agreeable that day when the little black colt came to the range world and tried to get a footing with his long wobblety legs on the brown prairie sod." I hope Henry likes it. I will read it myself.

October 16

Only four hundred bodies, or identifiable parts of bodies, have been recovered from the World Trade Center. Bereaved families have nothing to bury. With unimaginative kindness, Mayor Rudolph Giuliani has ordered more than four thousand small round urns of polished cherry mahogany. With all proper military ritual (the preparators wear white gloves), soil from the site is ceremoniously twice blessed and carefully deposited into each "five-inch-high urn, with 09-11-01 etched on the side. [. . .] Each urn will be presented in a blue velvet bag inside a black box. A family may choose to affix an engraved name plate on its flat top."[49]

Every day there are new biological warfare scares. Not enough urns for us all. And no urns for those we are killing.

October 17

From Tolstoy's *Resurrection:*
 "Could it really be that all the talk about justice, goodness, law, religion, God and so on, was nothing but so many words to conceal the grossest self-interest and cruelty?"[50]
 "There was no longer the comfortable darkness of ignorance in Nekhlyudov's soul. Everything was clear. It was clear that all the things which are commonly considered good and important are actually worthless or wicked, and [...] serve but to conceal old familiar crimes which not only go unpunished but rise triumphant, adorned with all the fascination the human imagination can devise."[51]
 "Why and by what right does one class of people lock up, torture, exile, flog and kill other people, when they themselves are no better than those whom they torture, flog and kill?"[52]
 "All these people—governors, inspectors, police officers, and policemen—consider that there are circumstances in this world when man owes no humanity to man."[53]
 "But human beings cannot be handled without love, any more than bees can be handled without care. That is the nature of bees. If you handle bees carelessly you will harm the bees and yourself as well."[54]
 "It now became clear to him that all the dreadful evil of which he had been a witness [...] and the calm self-assurance of those who committed it, resulted from the attempt by men to perform the impossible: being evil themselves they presumed to correct evil."[55]

October 18

The brush strokes I am making on *Nearer* remind me of the wave pattern woven into the Chinese silk tapestry that used to hang above the "Nancy Bliss Whitney" (a chest of drawers) outside mother's bedroom.

The film *Don't Look Back* realigned and invigorated me last night. The film shows Dylan live, his sheer courage: walking out all by himself onto a dark stage into a single beam of light, nothing between him and the throng who await his voice.

His harsh, carking, screeching, tender voice. I heard it for the first time in 1967. We had just returned from Japan, and one afternoon all of us went to this very movie. James didn't like it, and the children were restless. He said, "Let's go," and I said, "No," and simply sat there until the film ended and met James and the children outside the theater. Now that I think of it, this was my first domestic "no." A "no" that led two years later to the end of my marriage.

October 19

This visit to Yaddo is winding down. The work I came here to do is essentially done, conceived and now only to be executed.

I know in my bones that this is the last time that I will come to Yaddo.

I first drove through the granite gates and over the causeway between the two eastern-most lakes in my fifty-fourth year, and will drive out at the end of this visit in my eighty-first.

October 20

A sting in the tail of this visit. A new guest knew James during his days at the *Washington Post*. "Are you Jim Truitt's wife?" he asked me after dinner last night. Nemesis. A gray morning watches my tears as I sit up in bed remembering how much I loved Jim and how there was nothing and is nothing to be done about the fact that the high sea of my lovingness was broken on his rock.

October 21

I come into possession of *Nearer* more every day. Each new instance some subtle *recognition* of what I have meant in all these years of work draws a line under me: line under line under line tautens into a baseline. *Strait* moves beside me, precise and spare.

A few of us watched Jem Cohen's film *Buried in Light* after dinner last night. This was my second viewing, and like all veritable works of art it had deepened. Jem spent some months in the '90s moving about the cities of central Europe—Berlin, Dresden, Kraków, Auschwitz, Budapest, Prague—recording what caught him as he went. A child drinks her bottle, her plump eyelids close, she sleeps, but that's not all—in her sleep her body startles into a terrible convulsion, and then we see her no more. Walls—bare, relentless, endless, faceless walls—line streets slanting into more walls; sometimes a woman hunches low over the bags she is scarcely able to haul. Sometimes a man crosses a street, or walks slowly away down it. Sometimes it rains, sometimes the sun glitters. At Auschwitz, a capacious bin of hair, another of shoes, another of children's clothes topped

by a hand-knitted sweater that would have fit the baby whom we saw go to sleep, another of eyeglasses . . . Everything that is or was human has been drenched, has been wrung out, and has drained away.

October 22

Alexandra—she and Jerry spent last night in Saratoga on their way home from Toronto—says *Nearer* is a long, strong way from the work of the Beowulf scraps of 1999. She is putting me in touch with a conservator who may have an idea of how to get these heavy pieces of canvas up on a wall.

October 24

Yesterday morning I woke up before five o'clock and went straight to the desk in the studio with the intention of incorporating into this manuscript excerpts from a document I brought away from my archive at Bryn Mawr last July. "Editing in your mind," as Margot calls it, is risky, but was in this case a practical necessity. A block of twenty-eight single-spaced pages, dated February 5, 1948, to October 6, 1949, while interesting, would skew this record.[56]

James and I were married in September 1947. On the fifth of February, 1948, I was twenty-six years old and had been married for six months. A few months after our wedding, Jim moved from the State Department to *Life,* at that time the most glittering magazine in the United States. He never discussed this move with me at all, simply said one day, "We're moving to New York and I'm going to work for *Life.*" Perhaps he didn't talk

it over with me because he suspected that I wouldn't agree with him—which I did not. I felt sick and frightened to hear that he was deviating in the direction of success in the boldest, most worldly sense. *Life* stood for all I stood against. A magazine of photographs, all of them competent, many brilliant, it covered events all over the world in a way as inventive as it was at that time unique. Jim was, from his point of view, right to move, but his point of view was a shock to me. I had honestly taken it for granted that he was as idealistic as I was.

In May 1948 we moved to New York and lived there for three months. During this time we moved around New York and I saw clearly how very hard women worked to make themselves a part of a life that they do not stop to understand. We lived in Greenwich Village; I saw art exhibit after art exhibit in which talent was not enough. I saw how "artists" "were." I saw that groups could be fatal. During this time I never stopped trying to write, and kept on writing stories and ideas for stories—all in an attempt to understand what on earth was going on around me. I had been writing poems and short stories since 1944. None of these efforts were ever accepted for publication, with good reason: however honest they were too stiff, too awkward, too clumsy, and, while altogether too heartfelt, too intellectualized.

I wrote every morning, or almost. Page after page after page of observations with more or less superficial ideas. Pages in which I explored, one after another, ways in which I could fit myself into the scene in which I was living. I tried extremely hard to keep on understanding and just kept on failing.

We moved back to DC in September '48. What impresses me about the journal of these years, of this particular period, is that I wrote so many details and observed with so much care but without any central core or concept out of which I

was writing. That's the reason I think they all failed. They had felicity, that terrible curse of art. But I can also see, from my point of view at the age of eighty, that this person, this young woman, intended to do something. She just didn't know what. And then when we moved back to Washington we continued to be embroiled in what is called a social life.

At some point in January of '49 it occurred to me that I was on the wrong track. I had been trying to deal with what I saw around me by way of narrative. And the more I wrote the more I felt that it couldn't be dealt with that way. I simply wasn't able to invent a narrative of sufficient interest to me. I had less interest in narrative than I had thought, and no knack for how things happen in time. And one day, standing in my sunny dining room at 2514 East Place in Georgetown, it occurred to me that if I made a sculpture it would just stand there and time would roll over its head and the light would come and the light would go and it would be continuously revealed. It occurred to me that a sculpture simply stood and time went on around it.

For that reason I decided to study sculpture.

October 26

Every moment of my walks around the lakes is cherished. The trees are less glorious now, but no less beautiful, more so perhaps.

Yesterday three people who used to work here at Yaddo came to visit me. We sat close in a circle in my studio and talked over past times and new, caught up on the threads of our affectionate work together here in 1984 and gathered them into the present. An honor . . .

October 27

"Airplanes at their core are very simple devices—winged things that belong in the air. They are designed to be flyable, and they are. [...] If you remove your hands from the controls entirely, the airplane sails on as before, until it perhaps wanders a bit, dips a wing, and starts into a gentle descent; if you idle the engines, or shut them off entirely, the airplane becomes a rather well behaved glider."[57]

"The airplane is such a simple device that it seems sometimes not to have been invented so much as discovered."[58]

WASHINGTON, DC
November 1

Delightful—Sam and I drove down to Washington with entire pleasure in each other's company—but being home is a shock. Military planes circle the city day and night, the sky never stops growling. Anthrax was found in my local post office; for a while no mail was delivered.

During World War II I learned to live a decent life while carrying around a load of unhappiness that could never be put down. Personal unhappiness, of course, but way, way above and beyond that always knowing that human slaughter was being done at large.

As now, for reasons less justifiable. If we fight in this century, we should fight under the banner of global law. The young men and women flying the planes I hear over my head are defending us, citizens, but also—a gnawing fact—the commercial interests of an imperialist nation. I wish someone would initiate an effort patterned on the Manhattan Project that in World War II remarkably rapidly yielded the atomic bomb. This time a project

with the intention to yield life: an all-out effort to devise and promulgate the production of energy by way of the power of the sun, the wind, the thermal power of the earth itself. We in this rich country could render ourselves independent of foreign sources of oil and thus lead the world to peace. We would to boot solve the problem of the air pollution resulting from the burning of fossil fuels—actually of the material remains from creatures once as alive as we are ourselves.

Out of key these days, but "in dreams begins responsibility."

November 3

It interests me that could I absorb the meaning of those pages I wrote when I was in my twenties. Not until I had made my way through two years of failure to the black work of *Nearer* could I absorb the meaning of those pages I wrote when I was in my twenties. I wish that I as I am now could have been a friend to myself as I was then.

November 5

The years are throttling me. I am having trouble breathing. I sometimes have a tight feeling in my chest, in the apex of my body under my rib cage. If I do something about these facts I might enter the land of the unwell. Instead will soldier on.

Alexandra has written a paper in which she quotes François Fénelon, who lived in the court of Louis XIV at Versailles:

Nothing is more perilous to your own salvation, more unworthy of God, or more hurtful to your ordinary

happiness than being content to remain as you are. Our whole life is given us with the object of going boldly on toward the heavenly home. The whole world slips away like a deceitful shadow, and eternity draws near.[59]

At some point in this daily life of mine I will be forced to stop, to lie down, and to die. I learned at my mother's knee that a life is bestowed so that it may be lived as much as possible in goodness, may grow in wisdom, and when the time comes may be given back in honesty. Now that time is nearing for me.

"Boldly home"... The world is no home of mine. Its cruelty betrays its beauty.

When I was a child I used to love to play hard until dusk. But then—hot, scratchy, and sweaty in summer, cold, stiff, and numb in winter—I used to welcome the sound of a voice calling me to have a bath, to have supper, and to sleep, calling me home.

November 8

James Meyer's new book *Minimalism* is being reviewed.[60] Most cogently by Arthur Danto in the October *Times Literary Supplement:* "The New York artists now considered the central figures in the so-called Minimalist movement of the 1960s— Donald Judd, Carl Andre, Robert Morris, Sol LeWitt, and Dan Flavin—were united less by a common style or even a shared attitude than by a network of theorizing wrangles. [...] The austerity of their art was not correlated with tranquility of mind, for the pieces themselves were characteristically offered as embodiments of critical truths alternately advanced in polemical texts, of which the artists were frequently the authors."[61]

James Meyer's account and analysis of the five "central fig-
ures," to whom he discovered while researching the record that
I should be added, is masterly, and a rattling good yarn to boot.
He sets the flavor of what it is to be an artist, the waywardness
of it, its fated quality. The other "Minimalists," James told me,
felt their work as idiosyncratic as I did. Each of us autonomous
and, all theory aside, each of us impelled toward the plain.

Alexandra's son Sam Kusack is one of seven emerging
artists from Canada and the US whose exhibition, "Forward
Retreat," opens tonight at the Maryland Institute College
of Art.

November 10

Sammy is asleep in the guest room, his mother in the room
behind my head. At the opening a former student pointed
to Sam: "There's your grandson." I guess he recognized the
family ilk.

Last night at dinner (candlelight is now more penumbra
than illumination, people in older times must have been sorely
limited after sunset) we were discussing how we felt about our
mothers. Did we understand them? Did they understand us? I
was moved to tell the story of how one night her doctor and I
crossed the state of North Carolina in the wake of the ambu-
lance in which my mother lay unconscious on her way to Duke
Hospital, where she immediately underwent an operation for
the brain tumor that killed her four months later. Feeling the
whorl of family encircling me this morning, I remember that
the nurse in that ambulance with her is in her nineties, blind,
lives in Black Mountain, North Carolina, near the college that
had so much to do with the flowering of American art in the

last century. We write back and forth and occasionally speak on the telephone. Her voice is still strong.

November 11

At breakfast yesterday Sammy thought about using his middle name, Dean, from now on: "Dean Kusack." The name you sail under makes a difference. It was in Nova Scotia one misty summer morning that I decided to use "Anne Truitt" instead of "Anne Dean." Neither out of disloyalty to my father nor loyalty to my husband, but because of sound and touch: three Ts—so satisfactory on the tongue and in the hand—and in between "rui," a fluent run with the free-wheeling dot.

Dean's (am practicing!) sculptures have no sound, which is one of their strengths because they measure time, and move, and you expect machines to click and clack. So viewers are thrown back into psychological time, also noiseless, and are forcefully reminded of its sinister leach.

November 12

Henry Hill, my grandson, was five yesterday. Sam Truitt's birthday is today.

The morning after Henry was born Mary was exhausted and slept off and on all day. I sat beside her bed, holding her sweet baby against my heart so that he could still hear a heart beating and feel confident.

Sam was born in the middle of the day, by Cesarean section. We were doubly separated, by birth and by my having to be especially tended. When I came to myself, I was enclosed by railings

in a bed drawn close to a window facing into a sunset twilight. A young man, white-clad, an intern I vaguely assumed, sat silent on a straight chair on the other side of the bed. I was silent. Night fell. Eventually people bustled in, turned on a ceiling light, and pushed me to my room. There Sam and I were reunited in companionship we have shared ever since, as if in lingering reverberation of unity with an unknown silent white shadow.

November 14

The suspected weaknesses I used clumsily to try to forefend for my children have not plagued them. They evolved fates for themselves out of strengths I did not always distinguish.

November 15

Born in Vienna in 1909, E. H. Gombrich has just died in London where he lived since 1936. All his long life he rejected the cant that tends to grow like moss on art historians. "So much of what people write is just an expression of their own emotions."

On cultural relativism: "No doubt it is interesting when studying the arts of Florence to learn about the class structure of that city, about its commerce or its religious movements. But being art historians we should not go off on a tangent but rather learn as much as we can about the painter's craft."[62]

On meaning in art: in order to grasp the reality the artist aims to convey, the viewer must bring to the work of art a process Gombrich called "making and matching," i.e., the viewer's own experience must inflect and inform art. Understanding is *earned*.

November 17

On no more than an appreciative impulse I have engaged myself to be the guest at a Master's Tea at Berkeley College at Yale on November 29, and at a member's luncheon at the Cosmopolitan Club on March 19. On both occasions I am expected to speak.

I had no intention to become what I have become. What I remember was to do what I wanted to do when I saw clearly that I wanted to do it, and this is where I have ended up.

Yesterday my doctor advised me to "cut back"; "you will know what to do," he said. I do, but I feel like a hound dog trapped in a sling.

November 18

Thoreau said, "Beware of occasions requiring new clothes." The English suit I bought when *Prospect* was published is so well tailored that I could play tennis in it.

Two sentences hovering in the air over my head: *I had no intention to become what I have become. What I remember was to do what I wanted to do when I saw clearly that I wanted to do it, and this is where I have ended up.*

True enough, but not enough. Simplistic, not simple.

Actually, I took decisions. I find I think of them as lacking in narrative, that these decisions run on a line comparable to Heraclitus's convex-concave curve, the convex and the concave being at once opposite and identical. In my life on the line of inside/outside: mind/body.

Decisions to move forward in a direction from resource. Whether I turned inward or outward in deciding in any direction.

All critical.

More productive direction, too; resource is *inward*.

Shape of a rhizome.

My life has turned out the way it has because every time I had to
make a critical decision I referred it to the inside of myself instead
of the outside in my work. I consulted myself and no one else.

November 20

What I want to say at Yale and at the Cos Club is what it's like
to be an artist who has lived to be eighty and is still working.
Address first the source of my work; second, how I make it;
third, how I handle it in the world; and fourth, how I take care
that I am steady enough to keep going.

November 21

Too ambitious and off-key. At both Yale and the Cos I'll be
speaking to a normal comitatus. I must look up *comitata,* but
I doubt the Romans had the concept of a group of women
bound to one another by loyalty.

Need a title: "Portrait of the Artist at Eighty: Reflections,"
perhaps.

I need a sentence or two to open with, and a flexible
sequence beyond that.

Yesterday doctors measured me. I am to take a new medi-
cine on schedule: once again a problem and a solution.

I read somewhere that "despair is inbred," as if it were a
social solecism! A snobbish remark with a grain of truth: best
to catch and mend as you go along, to forefend the drag of

unsolved problems, the danger of the bitterness of having disappointed your own self.

November 22 (Thanksgiving Day)

My hair is washed. My clothes are laid out. My contributions to the feast, mashed potatoes and cranberry sauce, are ready. Rosie's birthday presents (her birthday is November 28, the day that I will be on my way to New Haven) are stacked by the front door. My car is full of gas. My traveling water bottle topped off. The [Patrick] O'Brian Aubrey-Maturin tapes I will listen to on my way to Annapolis are in my bag, along with my now indispensable cell phone. I am all ready for the treat of Thanksgiving, my favorite of all holidays.

* * *

An altogether grateful day. John telephoned to ask if he might pick me up and bring me home. I had not known how much I was bracing myself for the traffic until I heard his voice. Isabelle came with him: two, a halo of light fluffy hair, and a decided way about her. John's mother was there (we translated a book on Marcel Proust in the 1950s, when she was pregnant with John) and her husband; also Cicely Angleton and her family. Charlie was home from college; he had finished one of his two senior theses the day before—on Elizabeth Bishop. The other, in history, will be on Edmund Burke and Montaigne. Talk flew around the sunny table. Rosie and Julia carried plates. Henry and Isabelle gyrated pleasantly. Cicely read a Thanksgiving poem.

November 24

What I want to say at Yale is getting clearer. As of now:

A running skein of my life as narrative, the facts as anecdotal as the facts of any life, from the earthworm to the human. A narrative constituting an armature, as the column embodies an armature in my sculptures.

This armature of event is exoskeletal, animated by a sense of selfness I cannot remember ever not having.

This consciousness interests me more than linear narrative, so I thought I would tell you a little about its action.

When I read Marcel Proust, I realized that a knowledge I had had only instinctively could be put into *words*. Once so distilled, formulation itself contributes an expansion of consciousness that in turn leads to behavior initiating more expansion.

The development of this initial, instinctive self tells the true tale of my life.

It took me time to figure out what was going on. Vertical/horizontal: the horizontal being linear time and the vertical being my self ticking along on that line and learning up and down along it—spiritual above, physical below. Trismegistus: "As above, so below"—consciousness heightening only by the degree to which it deepens. To this formulation I added in the 1970s Deleuze and Guattari: the rhizome as the pattern of growth. The rhizome is a bulb—the iris flower grows that way.

It develops on a plane—no vertical—by way of ancillary movements, offshoots centralized by the rhizome's energy.

November 25

All, all too complicated.

Nonetheless, Four Turns:

1) A turn away from my sad family out into the world on my own, matched by a settling into the saddle of school work—and liking both ways.

2) Decision when accepted at Yale for graduate work not to go because what I really cared about and learned most from was the world at large.

3) Decision to "leave" my marriage, psychologically, as I had "left" my family, to leave failed attempts to write poetry and fiction, to leave failure altogether and to study sculpture—a sculpture stands clear in itself.

4) The turn away from material to concept in my work: had for twelve years, 1949–61, sought the source of art outside myself; realized suddenly that its source was inside myself.

BERKELEY COLLEGE, YALE UNIVERSITY
November 29

Charlie and I had tea at the Elizabethan Club yesterday. A small, simple, white clapboard house, prim among the buildings of harder stuff, granite and brick, gothic-windowed and towered and in the dusk glittering. Behind the club a walled greensward stretched to a knot garden around a pedestal upholding a marble copy of the only bust of Shakespeare thought to have been made during his lifetime. A portrait of Queen Elizabeth hangs in one paneled room, along with several letters penned in her elegant hand; her articulated signature is really a drawing. Charlie opened a door to reveal the formidable safe that holds the club's

folios. Two plaques are inscribed with the names of members killed in WWI and WWII.

These plaques are ubiquitous at Yale: name after name after name after name after name . . .

Charlie's roommate Ben had dinner with us. We discussed his senior thesis, which is on World War I writers: Rupert Brooke, Robert Graves, Siegfried Sassoon, Vera Brittain, Wilfred Owen (killed two days before the 1918 armistice), et al.

We walked in and out and around and about grass plots winding between the many-windowed, all-lit-up colleges, libraries, museums, and theaters that constitute the university. There are twenty-four libraries. They contain nearly ten million books. One, at the Beinecke Rare Book and Manuscript Library, is the Gutenberg Bible—imagine! It lies open inside a vitrine; every day a page is turned.

On the outside the Beinecke is a cube composed of modular planes of veined white stone; on the inside, this stone skin is perceived to be translucent. This translucent cube contains a transparent cube in turn containing row upon row of books bound in subtle leathers. If bombed—even by a nuclear bomb—this interior cube will (should) drop intact deep into the ground under it; the air will be sucked out of it. The elegant white exterior walls will fall inward, piling one on another to protect the enormity of a literary heritage.

I only saw the nucleus of the university. Wide flung on pseudopodia: law, science, architecture, medicine—the whole generous range of human endeavor.

I think of a decision I made in 1943, just after graduating from Bryn Mawr. I received the letter from Yale accepting me as a graduate student in psychology. It was while I was staying in my father's home in Asheville, North Carolina, that I was surprised to find myself uneasy. I took a long walk, sat on a grassy slope

overlooking a lake, realized that I cared more deeply about what I had learned outside the academic world than inside it, wrote the university refusing admission, and left the family roof to live and work in Boston. Today I see what could have been mine, a place here in which I might have developed in unimaginable ways. A place that would have perfectly suited me as an undergraduate—but that place was denied my generation of women.

The curator at the Yale University Art Gallery made me feel welcome. *Two* stood clear in a storage area. Early 1962. Forty years—the forty years of my life that it holds intact—half my lifetime ago. My hands moved a little as if I were painting it again. Mars black and Hooker's green straight from the jars; I hadn't yet started to mix color. I looked at it, remembered, and let slip as if unmooring a ship that holds intact forty years of my life.

November 30

John Rogers, master of Berkeley, and Cornelia Pearsall, professor of English at Smith and Rogers's wife, made the tea, and the dinner following it, so pleasant that we were all easy company, a *comitatus* of one evening. Eager exchange, all the more eager because to a degree formal, defined by context.

I found myself speaking of the shape of my life and work as if to tried and true friends.

WASHINGTON, DC
December 1

Meliorism has long seemed to me mealymouthed. I have been convinced that if society improves at all, rather more unlikely

than likely, it does so very, very slowly. But I am glad to find myself too cynical. The last three days I saw for myself change: the effects of the 1967 Civil Rights Act actualized in my grandchildren's generation.

Legal equity decreed social equity, and social equity decreed cultural equity; my grandchildren inherit a range of opportunity only as idealistically foreseen in my generation.

December 6

What I should have said at Yale was that I have gradually taken in the fact that I am not my body. And that because I am not my body, I have had to make an effort to understand it on its own terms. To learn its ways: when to demand (one more coat of paint) and when to give in (chocolate-covered graham crackers for dessert) without allowing it to run my life. If I remember to refer to it as I go along, I find it rather comforting to dwell inside a creature. The kind of comfort a dear animal provides, creature comfort.

I could have said that because it might have stayed this marvelous grand-generation to hear it. They would not have *believed* it—healthy skepticism—but they might have factored the idea into their complex lives. They take in so much so deftly. Mary, who teaches them, thinks that the speed with which their memory systems process information is faster than hers. As for me, I am colonial, and in that group could be mobcapped and candlelit. Furthermore, my ideas of space are positively ancient Greek. I think of explaining a geography, they a hyperreality without visible bounds.

December 9

This morning I climbed back upstairs, coffee in hand, very slowly—carefully. Last night fell asleep without reading, virtually unprecedented. Tired, bone-tired.

Might it be that my past is unfurling into my present?

December seventh was the sixty-first anniversary of the Japanese attack on Pearl Harbor: the classmate whom I ran to tell because both her father and fiancé were naval officers on the USS *California* now lives nearby—we stood side by side once again in exercise class.

I had lunch with four friends, three of whom I have known for almost fifty years. They through Mary Pinchot Meyer, about whom a writer has asked us to tell, so we have been remembering Mary together. For years now, I have answered all such inquiries with the sentence, "I do not speak about my friends for publication." The writer is serious, so I read one of her books, found it evenhanded and well researched, and invited her for tea. Because Mary has been savaged in several books— bald lies and vicious interpretations—I am thinking the matter over again. I may—only may, still turning the matter over in my mind—be coming to the feeling of responsibility to experience that incurs moral action. The memories are heavy. Not one person asking me about Mary has ever expressed decent sadness that she was abruptly and brutally put to death in broad daylight while out for a walk in her favorite blue-and-white sweater on a sunny October day.

Another friend fell this week and lay on the floor of her bathroom drifting in and out of consciousness for two and a half days before she was found.

Yesterday I went with friends to see a new film on Shackleton's 1914 expedition in the *Endurance*. Not so personal a past

unfurling into the present but a past—some years ago I read so much about early Antarctic explorers that I seem to myself a silent shadow among them. Yesterday I was with friends again, scanning Shackleton's face for signs of anxiety, watching the ice swallow my ship, sorrowing that Mrs. Chippy, the ship's cat, and the sled dog puppies had to be killed, shrinking in my rowboat under the towering, terrifying waves on the way to South Georgia Island, sliding down a steep, strange, frozen mountain finally to knock on the door of the Norwegian manager of the whaling station at Stromness Bay: "My name is Shackleton."

December 10

A stubborn woman living alone, forced to regard shrunken boundaries, I rethink the question of my final thesis at Bryn Mawr: What produces ego strength? What factors into the devotedness of a person who functions reasonably and steadily in fitful winds?

Roald Amundsen, say, the Norwegian discoverer of the South Pole. He almost to a fault consistently undercuts his Romanticism by being dry, competent, and practical. Fatally generous: when he was told that an Arctic explorer was lost and his help was needed, he put the book he was reading facedown, got into an airplane, and was never seen again. Ernest Shackleton: tested to the ultimate on the *Endurance* expedition. It was on South Georgia Island, a few years later, that he died, suddenly, of a heart attack. I have a photograph of his grave on my desk.

As I remember, the basic idea of my thesis was that of reliance on a more or less conscious ego. If the *I* is conscious, it "looks out," hence has an opportunity to balance itself. Hence an opportunity to tolerate unavoidable frustration. When the

time came, I tried to give that to my children to help them devise for themselves levels of aspiration neither too easy nor too difficult. So they would grow to come steadily more confident.

Now I have to see my own levels of aspiration the other way round: on a slope of decreasing capacities, ratcheting my behavior as intelligently as I can to keep stronghearted.

And now too I see, as I did in my twenties, complexities beyond any understanding I am at all likely ever to have. That is a happier state of mind than I would have guessed.

Like Marcel Proust, I am content to "believe in the predictability of everything."[63]

The possibility of nothing too, the matter of "everything" on Heraclitus's convex-concave curve. "We are and we are not," he says. The I who I am when I am a little at a distance, swayed in identification with my body, both is and is not. I practice to stay there, inside (in a Greek geometrical sense) the line of being/not being.

December 13

Toward morning I fell asleep again. I dreamed that I was walking on a cobbled road toward the sound of great bronze bells. It was before dawn. I was carrying some blankets. I was in a small Mexican town. I asked myself as I stumbled over the round stones why I was thinking of settling there when I had always "in real life" (I knew I was dreaming) so disliked Mexico. I rounded an adobe corner. There was the cathedral, its bells tumbling: I was before time for Mass. I found myself lying on my blankets on the street while I waited. People walked past me without comment. I felt *understood*. The sky was pale blue and into it the sun, round pure gold, started to rise. I woke up into the first glimmer

of understanding I have ever had as to why James so loved Mexico from the first moment we crossed its border in 1950. Perhaps he felt himself understood there, felt understood that part of himself that in me had lain down in the street. Perhaps his impulse was toward a natural human humility he found nowhere else.

December 14

Dark had overtaken dusk. I was talking with a friend in Connecticut when in a crashing second all electric light was obliterated. Distant sheets of flares crossed the black sky and two sirens wailed, separately. I recognized what I have half expected since 1944 when the atom bomb was invented: instant annihilation. "This is it," an utter banality. In a kind of mad calm, I made my way to the front door. On the street, a few minutes later, I distinguished the shadowy shape of a stalwart neighbor and friend, around whom other neighbors were soon clustering. A baby in arms cried. A little boy clutched his furry panda. We adults spoke in chorus. Order emerged: a local outage, would be fixed in a couple of hours.

It interests me that I was not more frightened—no adrenaline, no panic—and that I said no prayer.

I feel as if I recognize my life as I live it. In the plunge into darkness and the assault by sirens I recognized my own death—but was mistaken. Just so other "recognitions"?

December 15

Starke and I picked out a Christmas wreath and drove to Arlington Cemetery where she placed it on Cord's headstone.

Row upon row upon row of identical white markers marked in the order of lifelessness. I count their years: eighteen, nineteen, twenty, twenty-one, twenty-two . . .

"It seems to us that the spring has gone out of the year.
Said Pericles, honoring war dead."[64]

And now World War III looms over those full fields. People in vigor forget. Elders remember. But our voices are become dry leaves on a wind that is bearing us away.

December 19

Tomorrow is the solstice.

Day before yesterday I saw a gentle little plum tree in bloom. *Ume* in Japanese, harbinger of spring. But we have had no winter.

Jill Baumgaertner (we met at Yaddo last October) has sent me her book, *Flannery O'Connor: A Proper Scaring*. O'Connor was born in 1925. When she was twenty-six she was diagnosed with systemic lupus erythematosus, so she lived one third of her life sliding toward dying: "You have to cherish the world at the same time you struggle to endure it."[65]

On a farm in Milledgeville, Georgia, was where she cherished it. She lived with her mother right down on the red dirt like her own characters, among her flock of peafowl. When I think of O'Connor herself I see the flaming fanned tails of peacocks and hear that scream in their feathered throats not unlike the voice of her writing.

"Quoting Robert Fitzgerald, O'Connor wrote, 'It is the business of the artist to uncover the strangeness of truth.'"[66]

Business . . . uncover . . . strangeness . . . truth. Yes. A step more: it is the rightful task of the artist to discern *a* truth and

to accept the *fact* that this personal scintilla is a gift unsummoned, unpreconcieved, and unmanageable.

The gift of an artist is to know that a truth exists, to each a truth, specific, neither physical nor theoretical. *A* truth to which and for which each is responsible. A truth always strange because it cannot in wildest dream be preconceived. *Its* business is its own. The artist's is to look, make, to translate.

In *A Proper Scaring,* O'Connor's picture of herself differs from mine. In her painted *Self-Portrait* (1953) with peacock it is not the peacock's tail that she paints but his gaze; four eyes *look*.[67] Look out. Look at.

Winter

December 20

The solstice. It is 5:05 a.m. and no light in the east. The dark is good. I do not *always* want to look.

Proust speaks of moments of bliss stopped and fixed in his memory. What is stopped and fixed in mine is not so authentically reflective: I remember what I am not forgetting. O'Connor's "strangeness of truth" can be Joyce's "agenbite of inwit."

The conscience of age is appalling. Dry, exacting, it sifts the matter of a lifetime and renders verdict.

In our house at 1515 Thirtieth Street in Washington, the house we lived in from the spring of 1960 (Sam was born into it) until the spring of 1964 when we moved to Japan, a long straight flight of steps on the left of the front hall led up to the second floor. One bright midday in 1963 I heard odd noises and went to the top of these stairs and looked down. The front door was open, autumn sun was streaming in, full on two caryatids, a tiny wizened female and a tiny wizened male bearing instead of heads obscenely huge round painted balls. The sounds stopped, the little bodies stood still, I stood still. These strangers repelled me. They were outrageous. I felt outraged. I was opening my mouth to order them out of my house when they lifted their twigs of arms and hoisted the balls, congratulating themselves, laughing, capering with delight: two friends had stopped by to show me their Halloween concoctions. Of course I laughed and ran down the stairs and admired and waved them off in their convertible with the two papier-mâché balls rolling against each other in the back seat.

But I was, for the first time in my life, glad to see them go. They had diminished themselves, literally. I had not known that without their heads their bodies were childish. And I was taken aback. So F. Scott Fitzgerald, right in the plain middle of the day.

These were "the Kennedy Years." The sun beamed on my generation, briefly but brilliantly, like the light behind my two friends at the foot of the stairs. Power, not papier-mâché, swelled our heads.

The way it turned out was that John Kennedy was killed before his natural authority, his intelligence, address, and high heart, had time to mature. The "truth" that time inevitably "uncovers" in a character has stopped under the flicker of his commemorative flame.

Jacqueline Kennedy lit that flame: under which she is now also buried.

Style, writ like a gesture in the air; a memory of promise.

December 22

Yesterday the son of dear friends—I first met him as a little boy in knee pants—brought his granddaughter for tea. Miranda is five. She wanted to see where she was, and we walked from attic to basement before we settled down to read *Madeline* and *Hiawatha*. She has her great-grandfather's very open pale blue eyes, identically fringed by sooty lashes.

Much that happens to me now seems to move on the glassy surface of a lake beneath which I, alone, wonder at the architecture of my life.

December 28

"You need never be cold again," Alexandra and Jerry said when I opened their Christmas present, a large, soft, elegantly fringed dark-gray cashmere blanket, now spread over my feet.

I am back home, warmed by more than cashmere. Reinforced, yet a little daunted too. Jerry escorted me carefully through the Stamford railway station yesterday. As I humped and stumped toward the train I reached the end of my personal thread. I felt like a pebble in a cement mixer, senseless in the public grind.

December 30

Nearer is not the name of the series I made at Yaddo. *Res,* perhaps. Res Publica Romana: the Roman "thing." *Thing:* things is what they are, not "art." I am making more.

January 1, 2002

One silent hour into the year two thousand and two . . .

January 7

It is not the Roman *res* that I have been thinking myself for the past few days obsessed with but "race." No wonder I have been feeling sad. Long walks and cherished books and favorite meals and rest in my warm bed have been failing me. I have been coming, and now have come, rather as one might arrive at a destination, to the fact that my own private race is almost run.

The pith of my bones stirs in alarm.

January 8

Core, perhaps. *Cor* is the medieval French word for heart: the core of earth; the heart of a matter. The core of my sculptures is gravity.

January 9

Charlie is here. We have put *Swannanoa* up on sawhorses; now I can undercoat the bottom: pure Hansa yellow, to watch from underneath the ten or so crisscrossed coats I have already painted on the eighty-one-inch column. Hansa yellow looks forthright but is not. Its ambiguity will animate what I intend the sculpture to be.

Not *Core.* Threw out one of these works yesterday and almost at the same second saw that another was finished.

Charlie's presence tips my days into pleasure. We are for each other a palimpsest. His babyhood and early childhood underlie my old age. He helps me over the same bumps in the geography around here that I used to help him over, braces my mittened hand, and I hear in his voice the encouragement he once must have heard in mine. Sometimes I wish we were back there, Charlie drowsy in his crib and Mary singing "Moon River" for us both in the summer twilight.

January 10

I have lately had to look at the fact that from my eighty-year-old perspective some of the friends I have long treasured in my memory were not what I thought they were. This is not their fault, nor mine, really. Perception can only be

contemporaneous with development. Nevertheless, reexamination of certain years of my life is making me sad even as it unmoors me from them.

Color gone forever? Only *Swannanoa*. Then black and red. I see that I have not nailed down enough my first insights of 1961. *Twining Court I, II* . . .

January 13

I am, I think, alighting on *Thing,* plain and simple. 1, 2, 3 . . . Have destroyed their 1999 predecessors except for the large paintings, which I need help to slash. I will strip them off their stretchers, which I will give away. Traditional framing: *Things* floated on pure white, closely bound by uniform mats of the same white, inside white frames as narrow as feasible.

Swannanoa is stirring.

I did not have time to make the torrent of sculptures that descended on me in the early '60s. Then I had money (inherited) but not time; now I have time but not money, and not energy. But what I have I have. No more paintings. No more color for its own sake, to find out what it might be. No more letting it out into space and expansion. Enclosure, gravity enclosed.

Sculpture *Twining Court* may be *Twining Court I*.

January 14

I think so. One armature, eighty-one by eight by eight inches, standing bare in the studio: *Twining Court II*. The other day I drove into that alley between O and P Streets, into what was once Twining Court. Obliterated. The backs of the town houses

that were built on the footprint of the former red-brick stables that was my studio.

Rats who lived there, and I, gone.

January 17

> Your whole mind and body have been tied
> To the foot of the Divine Elephant
> With a thousand golden chains.
> Now, begin to rain intelligence and compassion
> Upon all your tender, wounded cells
> And realize the profound absurdity
> Of thinking
> That you can ever go Anywhere
> Or do Anything
> Without God's will.
> — From "Wayfarer" by Hafiz[68]

January 19

The air smells iron: snow. I intend to go back and forth between the house and the studio all day long, flattening a path in front of me under my Australian Ugg boots.

Swannanoa: more undercoats, color now. *Twining Court II:* gesso. New *Things:* they cover my whole four-by-eight-foot board, going into black this morning.

January 20

That's not what happened. Cicely's daughter called to say that her mother was in the hospital. I kept on trying to work but had to give in. My hands felt like cold stones.

January 21

Cicero wrote that if death were obliteration, he would not when dead know that he had been obliterated. If consciousness persisted after death, so much the better. Perhaps he remembered this rationale when he stretched his neck to the swords of Mark Anthony's assassins; perhaps not.

Once when I was a young girl, waiting for Aunt Nancy to pick up something at a farmhouse on a Virginia hill, I saw one end of a rainbow. All the colors remained perfectly distinct, intact until it disappeared into the raw red Albemarle County clay. The rainbow was as actual as the farmhouse until that moment when in dissolving it revealed itself to have been air.

Just so a dying person may discover that personal consciousness is universal.

January 22

I am so relieved. Cicely's condition is stable.

Pith
 Webster: "A usually continuous central strand of spongy tissue in the stems of most vascular plants that probably functions chiefly in storage." Memory.

"The essential part: core; substantial quality (as of meaning)"
Synonyms: concise, "tersely cogent"
"Pithy adds to SUCCINCT or TERSE the implication of richness of meaning."

January 23

Eight new *Pith*s lie finished.

Over and over I have fought the battle of "self-expression." The channel between what I know and my hand opened in my first year of college when in the biology lab I was expected to draw what I saw in the microscope. It never occurred to me that I couldn't draw, but the fact was I couldn't. A house was a square with a rectangle for a door, two squares for either side, and three above for windows. A tree was a fat shape on top of a thin rectangle. Perhaps partly because I did not see clearly until I went to public school in the fifth grade and my nearsightedness was discovered. Perhaps partly because I "saw" in a kind of clumsy abstraction. Perhaps partly because what I discovered on my own, walking and skating and riding my bicycle, swimming and boating, all had to do with my whole body. In any case, put to it in the biology lab, I discovered that drawing was delightful. I looked at the amoeba and saw it for what it was, a moving shape, no more, no less, whole, and stilled and recorded it with a very sharp pencil on very clean white paper. A transaction: my hand served my brain. As they served my feelings when they handled clay. But when they got paint into them the paint became grandiloquent and I had to teach myself the restraint I have experienced all my working life. Until 1999, when, to my surprise, emotion began to surge into my eager hands and from there into paint. Into *Pith*...

January 24

Cicely has leveled off, but her sudden violent illness has revealed to us, her friends, our generation's short slippery slope to death.

February 5

The telephone woke me: Isabelle thanking me for the large, furry, floppy cream-colored bear I gave her for her third birthday, today. For a second or two I heard only a generic grandchild's treble, I a generic grandparent, Isabelle and I abstractions.

February 7

I tried to go out to the studio just after dawn but the kitchen stairs are icy. I aimed to put arrows and #26 and #27 on the backs of the new *Pith*s, and to look at *Swannanoa* and at *Twining Court 11,* now in its first coat of gesso. To look because I was suddenly overcome early this morning by the *conviction* that *Swannanoa* is actually a column of its color, and *Twining Court 11* a column of black, and every future sculpture a column of whatever color it is. No proportions other than intrinsic scale.

February 11

Dawn. I'm right about letting color be: my eye slid out into the spaces between scarlet and blue, not taking note, as they used to, of edges.

Swannanoa—six or more coats. Eighty-one by eight by eight inches of layered yellows, orange-reds, and oranges. Color saturated yet diffused, like one of the rays of the rainbow I saw that day so long ago disappear into the copper mud of Virginia.

Twining Court 11, then a sculpture I have been thinking about since 1962: *Shenandoah*. Then one more column, and two chunky and two thin *Parva*s. I will have to use capital funds. Imprudent, heaven knows, but heaven can protect too.

This writing is *Yield: A Working Journal*. Limited. Continuing. Will turn into a manuscript but not publish unless my working life comes to an end.

February 13

My new driving license is valid for five years. A friend, who came for tea, says I look fine in the identification photo; I was surprised myself—I stand against a sky-blue curtain, my puffy jacket flung wide from my throat at a racy angle, my hair by some alchemy returned some color akin to native yellow and the whole fuzzed up. I look fresh. A closer look though showed my throat to be a wattle. Vanity . . .

One of my happiest memories is being taught to drive by my cousin Nancy. She was fifteen, I thirteen, and we were addicted to backgammon—quaint in these days when girls our age sport rings in their navels and have to make decisions about contraception and drugs. We used to drive a Willys-Knight touring car out to the barn, play a game, drive back up to the house then down the steep hill to the creek and play another game. That was the summer of my fourteenth year. A few days after my birthday, Nancy drove me into Charlottesville. A pleasant man said, "How old are you?"

"Fourteen."

"Can you drive?"

"Yes."

He handed me my first license.

February 14

While I waited for my coffee (coffee from Kenya, echo of Isak Dinesen) to drip this morning, I found myself looking out the kitchen down at the studio, and suddenly realized that right there in that rectangle I am most at home on the face of the earth. I drew it before it existed, in scale for the architect to copy, and could indeed have drawn it at the age of six: three walls of windows in a grid of gray shingles; the western wall is without windows, but has wide double doors opening onto the alley. It is practical, warmed in winter, cooled in summer, supplied with hot and cold running water. It has become, I think, beautiful by way of use. Like a favorite cooking spoon, worn but shapely.

February 16

> The eternal irreconcilability between the dedicated life and the personal life. [. . .] Although every serious person is expected to feel a responsibility toward his work as well as toward the people he loves, there is a point beyond which his devotion to his work cannot go without arousing the antagonism and jealousy of the people who love him and whom he loves.
> —Katharine Butler Hathaway, *The Little Locksmith,* 1942[69]

K.B.H. was born October 2, 1890, in Baltimore. Moved to Salem in 1895, contracted tuberculosis of the spine, probably infected by raw milk.

Age five to fifteen strapped to a board. Hopelessly deformed, no taller than a ten-year-old child; curvature of the spine—hunchback, like the "little locksmith" she knew as a child.

Not "eternal irreconcilability." Eternal challenge. Interesting too, and necessary for growth.

"Dedication" is a fancy word. Rather, a kind of dumb tenacity lives inside certain people and keeps on going no matter what else is happening. I myself am as ruthless to "me" as to others. This beast hurt James when I was married to him, and might have hurt my children had they not had instinctive generosity. I owe a debt to my children's understanding.

February 17

Michael Richman and I walked around three possible sites for a prospective Eisenhower memorial and drove around three others. Michael views the city as topography articulated by L'Enfant's radiating circles and punctuated by architecture.

The Potomac River yesterday was aglitter in the warming sun, slopping and slapping against its grassy banks. A slow slap that made me homesick for my native tidewater. One of Michael's favored sites would place the memorial along these banks on an axis from the Capitol Dome on the northeast to Arlington and the Tomb of the Unknown Soldier on the southwest. I took in Michael's geometry with pleasure, its range and scale, the city as earthwork. But I was surprised by my fierce resistance to placing any art whatsoever in it. All I could "see" were trees, some from each state, say, and easy benches in the

shade, perhaps placed near granite flats carved in commemoration of Eisenhower. The man who had the nerve to order blood spent for freedom.

Michael and I darted into the Hirshhorn Museum to take a look at *Night Niaid,* 1977, on view in an exhibition of the museum's holdings: "Minimal Art and Its Legacy." The curators had placed it up on a platform, a practical device to protect it from encroachment but a detriment as its meaning depends on its paleness springing up out of the darkness that grounds it in human space. 1977. Even though I made it myself, and remember clearly making it, I felt respect for it. And, if I am honest, for myself too. A close-run thing: hue, value, saturation, proportion.

February 19

"Thy will be done" is, when all is said and done, the only cogent prayer. Though we know neither Who nor What nor How. The toes of Hafiz's Divine Elephant look like cliffs.

A silver cord is said to hold us to these lives into which we were born; cut at death. Leaving in place, I begin to understand, a golden cord lightly attached to us all. A golden cord thin as silk and infinitely strong. So tethered, by the silken threads, we flow, so to speak, out of silver and into gold, into light, infinitely alluring.

Two *Pith*s are on their way into Renato's hands.

February 20

I feel *so* uneasy: The concept of boundary is fading out on me.
The *Pith*s are about that. And *Swannanoa*. A change behind my
own back, like that I made way back in 1945 from psychology to
writing, and in 1949 from writing to sculpture.

I feel like hiding. Today I will lie low. Read about Harold
and the Battle of Hastings, 1066, all said and done, safe. Make
chocolate chip cookies, without nuts, for family lunch tomor-
row in Annapolis. And finish and sign the bottom of *Swannanoa*.
Walk—with the physical balance of my cane to underwrite
psychological balance—and look at the buds plumping up on
the trees. Breathe in and out and not think.

February 22

Just as a personal life is keyed to a particular dance of heart and
breath, a family life has a rhythmical beat. Creature compatibil-
ity, consoling.

February 23

In the last year of his life, 1940, F. Scott Fitzgerald earned in
royalties from his books thirteen dollars and thirteen cents.

February 25

The newly renovated Botanical Gardens, on the mall just
southwest of the Capitol, are dispersed under a high glass roof

like that of Victoria's Crystal Palace, which I saw when I was ten. Tropical forest, desert, mosses (like Kyoto's moss garden), orchids—foams of orchids; leaves as large and as tiny as elephant's ears and bat's ears; ladybugs striped and stippled and spotted and streaked . . . and yet, and yet . . . fascinating but flat. I missed art. I missed transformation: Blake, Chartres, Goya, Rembrandt, Chardin, Fantin-Latour, Manet. One summer afternoon years ago I showed my little children that the sun shining through a piece of glass would ignite a piece of paper. I missed ignition. The blaze of human intelligence.

March 1

Just in from a coat of paint. The sky is blanched by a full moon. I scarcely needed my flashlight. I am so grateful to be able to put on my comfortable paint-splattered quilted jacket, familiar, soft from years of washing, and to go out to the studio on my own legs.

I have made Alice a small work on paper for our birthday fifteen days from now: a kind of "fence," pencil and pale blue. To keep her company in her workroom looking out over her garden to the ocean.

Alexandra telephoned from the Taj Hotel in New Delhi. She is due at Kennedy tomorrow at 2:00 p.m. Incendiary riots in New Delhi: I think of my dear daughter's birth, her babyhood, all the days and years of her life. I cherish her independence. But I will be relieved to have her back on the same piece of land, to know that I could walk to her.

March 3

F. Scott Fitzgerald lies with his forebears in the churchyard of St. Mary's, Rockville, Maryland. His wife lies by his side, his daughter at his feet. Three huge ancient oaks are all that remains of the continental primeval forest, now replaced by humming highways that intersect to isolate the promontory on which the church stands, making a kind of ironic ecclesiastical close.

I had flowers with me yesterday. Others had been there before me. A coil of pearls echoed those that hung down Nicole's brown back in *Tender Is the Night*. Five separate single red roses had faded to the bronze of the ribbon around some stems too wilted to name. Small valentine candy hearts lay scattered about, motley on the granite covering the graves: "So we beat on, boats against the current, borne back ceaselessly into the past."

March 5

It is our own past into which we are borne. Into the lives we must strive to get straight in our heads so that, like geese, we can gather ourselves and take off when summoned.

March 19

(Notes for Cos Club)

Believe in:
Power of tenacity

Power of revelation
Existence of (divine) grace
Interconnectedness of all things
Mutual integrity of all things
Order of all things
Teleology of a life

Striving to understand because honest acceptance depends on understanding, and acceptance adumbrates submission, and we all, finally, lay down our lives, submit to the law of all and everything, of change, transformation, of all and everything.

Spring

March 25

A train whistle blew through my room a few minutes ago and woke me up with the words Atchison, Topeka, and Santa Fe singing, and the feeling of prairie grasses rising and falling, sweeping and twisting, in a wind that somehow included me.

March 30

When rested, as I am this early spring morning, I feel balanced in this point of view, poised on my own pivot because all and everything is one in a singular animating force. That force is all that is real. All that is individual is the inflection of minds that serve as mirrors reflecting, refracting the force of origin. Oh dear, that sounds like Aristotle's "self-contemplating god," to whom I so objected in Bryn Mawr at eighteen! Seemed to me selfish and narrow. I was selfish and narrow—could not, as I can now, conceive of infinite force that *could* only self-contemplate because all is that "self."

Will work on a very large new *Pith,* #28. Will start round *Pith*s, piling up out of my own energy (remnant—I guess soon to be called back into whole like a child, a tired child, at the end of a long day) what's needed to make the work itself a *Ding an sich.*

Will order two more eighty-one-by-eight-by-eight-inch armatures. And four *Parva*s.

Will then cut my life to suit the warm cloth I have left in my body.

I am somehow delivered back into the content curiosity I felt at the start of my life.

Content because I was secure, curious because being alive was new.

Fourteen days into my eighty-second year.

ANNE TRUITT
Selected Chronology

1921
The artist is born Anne Dean in Baltimore, Maryland, on
March 16.

1934
Truitt and her sisters are sent to live on her maternal Aunt
Nancy and Uncle Jim Barr's farm outside Charlottesville,
Virginia. Jim's brother is historian and author Stringfellow
Barr, who will cofound the Great Books Program at St. John's
College in Annapolis, Maryland, in 1937.

1938
Entering Bryn Mawr College at age seventeen, Truitt is a year
younger than most of her fellow students. In November she
almost dies from peritonitis brought on by a ruptured appen-
dix. She is required to leave Bryn Mawr College to recuperate
for the rest of the year.

1939
As part of her physical recovery, Truitt takes a rehabilitative
exercise course at Highland Hospital in Asheville, North
Carolina, during the summer. This firsthand experience with
progressive treatments furthers her interest in psychology.
She resumes her freshman year in the fall. Among the sub-
jects that Truitt studies are Greek literature in translation,
Renaissance and modern art, philosophy, psychology, and
creative writing.

1943–44

Truitt graduates cum laude with a bachelor's degree in psychology from Bryn Mawr College. She returns for the summer to her father's house in Asheville, where she works as a Red Cross nurse's aide.

Truitt is admitted to Yale University to pursue a doctorate in psychology but declines to attend, realizing that she prefers to work directly with people. She joins her sisters in the Boston–Cambridge area and begins a job at Massachusetts General Hospital in the psychiatric lab. She takes a second job at night as a nurse's aide in the same hospital: "The more I observed the range of human existence—and I was steeped in pain during those war years when we had combat fatigue patients in the psychiatric laboratory by day and I had anguished patients under my hands by night—the less convinced I became that I wished to restrict my own range to the perpetuation of what psychologists would call 'normal'... I honestly do not believe that I would be an artist now if I had not been first a nurse's aide."[1]

Truitt continues to write poetry and short stories.

1946

In the spring, Truitt becomes aware of the limitations of her role in professional psychology during a psychiatric testing session with a patient. She leaves her position as a psychiatric assistant but continues her job as a nurse's aide.

1947

The artist marries James Truitt on September 19 in Washington, DC, where he works for the US Department of State.

1948

Truitt accompanies her husband to New York when he leaves the Department of State to work as a journalist for *Life*. While in New York, she works administering psychological tests. James Truitt is transferred back to Washington, DC, in September. From February 1948 to October 1949, Truitt keeps a journal that chronicles her growing frustration with the limitations of narrative writing and her increasing interest in the visual arts as a means of expression.[2]

1949

On February 8, Truitt begins attending the Institute of Contemporary Arts in Washington, DC, where she studies sculpture with Alexander Giampietro.[3]

1952

Truitt uses a small coach house in Georgetown as a studio. During the years she spends at this studio, Truitt will work in many different ways: building figures, including life-size torsos, out of colored cement, clay, and Sculpmetal, as well as carving stone. She also begins to layer and solder wire into geometric constructions, painting some sections.

The artist is involved with the Institute of Contemporary Arts. The Institute will invite a range of speakers whom the Truitts entertain in their Georgetown home, including Truman Capote, Marcel Duchamp, Naum Gabo, Bernard Leach, Alberto Moravia, Isamu Noguchi, Sir Herbert Read, Hans Richter, D. T. Suzuki, Rufino Tamayo, and Dylan Thomas.

1953
Truitt cotranslates Germaine Brée's book *Du Temps perdu au temps retrouvé: Introduction à l'oeuvre de Marcel Proust* (*Marcel Proust and Deliverance from Time*) from French.

1955
Truitt gives birth to a daughter, Alexandra, on December 2.

1957
The family moves to San Francisco, California, where James Truitt has been made bureau chief for all *Time* publications.

1958
Truitt's second child, Mary, is born on March 27.

1959
By 1959, the family has moved to San Francisco's Divisadero Street. A room on the third floor serves as Truitt's studio, where she makes drawings in black, brown, and pink ink on newsprint. Truitt socializes with artists and writers, including Anthony Caro, Richard Diebenkorn, Clement Greenberg, Louisa Jenkins, and David Sylvester. The Truitts also take frequent trips to Big Sur, where they own land on Partington Ridge, and spend time with archaeologist Giles Healy, who was the first non-Maya to see and photograph the Maya site of Bonampak in 1946.

1960
The Truitts return to Washington, DC, in July when James Truitt accepts a position as assistant to Philip Graham, publisher of the *Washington Post;* by 1963, he will have been appointed vice president of the company and publisher of

ARTnews, then owned by the Washington Post Company. The couple is part of a lively social circle of journalists, artists, politicians, and government officials, based largely in Georgetown. At a dinner party at Mary Pinchot Meyer's house, the artist meets David Smith. He will become a friend and an important source of information about making a life as a sculptor. Samuel (Sam), Truitt's third child, is born on November 12.

1961

On a visit to New York in November, Truitt views the work of Ad Reinhardt, Barnett Newman, and Nassos Daphnis for the first time, in the Guggenheim Museum's exhibition *American Abstract Expressionists and Imagists*. She will later observe that this encounter exposed her to the conceptual possibilities of art.

1962

Truitt rents a carriage house at Twining Court near DuPont Circle in Washington, DC. There she makes or initiates at least thirty-five sculptures and a number of works on paper over the course of the year.[4]

1963

Truitt's first solo exhibition at André Emmerich Gallery in Manhattan opens February 12.[5] Donald Judd, whose work will become closely affiliated with the emerging Minimalist aesthetic but will not be the subject of a solo exhibition until December 1963, briefly reviews Truitt's show for the April edition of *Arts Magazine,* observing that "the work looks serious without being so."[6] Michael Fried also mentions the show in a review for *Art International*.

1964

Truitt's work is included in the group exhibition *Black, White and Grey,* organized by Samuel Wagstaff for the Wadsworth Atheneum Museum of Art in Hartford, Connecticut.

James Truitt accepts a position as Far East Bureau chief for *Newsweek*. The family moves to Tokyo in May, remaining there until 1967.

1966

Truitt's work is included in *Primary Structures: Younger American and British Sculpture* at the Jewish Museum in New York, organized by Kynaston McShine. During an overseas trip to Washington, DC, in the spring, Truitt meets curator Walter Hopps.

1967

The Truitt family returns to Washington, DC, in June when James Truitt becomes a general correspondent for *Newsweek* and the first editor of the *Washington Post*'s Style section.

1969

The Truitts separate in February, although their divorce will not become official until March 1971. Truitt takes primary custody of and financial responsibility for all three chil-dren. In May, she buys a house in the Cleveland Park area of Washington, DC, where she will live for the rest of her life.

By the late 1960s, Truitt, who as a child attended Episcopalian services with her family and had remained an Episcopalian, has also been introduced to the moral philosophy of George Ivanovitch Gurdjieff (1877–1949). Around the same time, she begins to follow the teachings of Radha Soami Satsang Beas, a nonsectarian spiritual organization, originating in India, which

leads her to follow a lifelong practice of vegetarianism and
daily meditation.

1973
The Whitney Museum of American Art mounts a retrospec-
tive of Truitt's sculpture and drawings, primarily organized by
Walter Hopps, from December to January 1974.

1974
On April 21, an expanded version of Walter Hopps's retrospec-
tive of Truitt's sculpture and drawings opens at the Corcoran
Gallery of Art. On a trip to Arizona in June, Truitt begins the
journal that will later become *Daybook*.

On the recommendation of artist Helen Frankenthaler,
Truitt is invited to Yaddo, an artist's residency program in
Saratoga Springs, New York, for the first time. She will return
to Yaddo throughout her life, working on sculptures, drawings,
and the manuscripts for all four of her books.

1975
In March, Truitt spends two weeks in residence on Ossabaw
Island, Georgia, and comes to realize that her journal begun in
June 1974 might become a viable manuscript (*Daybook* will be
published in 1982). She visits Yaddo for another residency.

In the fall she begins teaching as a part-time lecturer in the
Art Department of the University of Maryland, College Park.

1980
Truitt is promoted from lecturer to tenured full professor at
the University of Maryland.

1981

In September, while at Yaddo, she writes her preface for *Daybook*.

On November 17, James Truitt commits suicide at his home in San Miguel de Allende, Mexico.

1982

Truitt begins writing the journal that will become her second book, *Turn*. Pantheon Books publishes Truitt's first book, *Daybook: The Journal of an Artist,* on October 12.

1983

After discovering salary inequities between herself and a male colleague at the University of Maryland, Truitt initiates litigation against the university, hoping that this action might establish greater pay equity for other female professors. In early September, faced with the financial drain of a prolonged court case, Truitt drops the lawsuit.

1984

The artist begins a yearlong sabbatical from the University of Maryland. She travels to Paris; Asolo, Italy; and London, which she will write about in *Turn*. Truitt serves as acting executive director of Yaddo from April 1 to December 31.

1985

In October, Truitt is invited to Lincoln, Nebraska, to give a series of talks on Willa Cather as well as her own work at the Sheldon Memorial Art Gallery and the Lincoln City Library. Truitt visits Yaddo from December 13 to 23 and completes final revisions to *Turn*.

1986
Viking Penguin Books publishes Truitt's second book, *Turn: The Journal of an Artist*.

1991
Drawing on journals begun two weeks before her retrospective and kept during her 1989 trip across Canada, Truitt works on her third book, *Prospect,* while in residence at Yaddo from December 18 to January 5, 1992.

1992
Anne Truitt: A Life in Art, a retrospective of Truitt's work organized by Brenda Richardson, is held at the Baltimore Museum of Art.

1996
In October, Scribner publishes *Prospect: The Journal of an Artist*. After the fall semester, Truitt retires from teaching at the University of Maryland.

2001
During her residency at Yaddo, from September to October, Truitt works on the *Pith*s, a numerically titled series of individual canvas works painted in black acrylic on both sides. She will continue working on this series for the next three years.

James Meyer's book *Minimalism: Art and Polemics in the Sixties* discusses Truitt's sculpture in relation to Minimalist aesthetics and theory.

Truitt begins the journals that will become the manuscript for her final book, *Yield: The Journal of an Artist,* the fourth volume of Truitt's memoirs.

2003
From October 1 to November 2, Truitt is in residence at Yaddo, where she makes two series of works on paper: *Sound* and *Waterleaf*.

2004
She completes several sculptures and finishes the *Pith* series of paintings on canvas.

Anne Truitt dies in Washington, DC, on December 23, leaving one unfinished sculpture.

NOTES

Yield

Epigraph: Epigraph to Marcel Proust's unfinished novel *Jean Santueil,* quoted in Edmund White, *Marcel Proust: A Life* (New York: Viking, 1999), 67.

1. Lafcadio Hearn, *Glimpses of Unfamiliar Japan,* vol. 1 (Boston: Houghton Mifflin, 1894), 29.

2. Jennifer S. Lee, "In China Computer Use Erodes Traditional Handwriting, Stirring a Cultural Debate," *New York Times,* February 1, 2001.

3. Michael Fried quoted in Rosalind Krauss, "A View of Modernism," *Artforum,* September 2, 1972, 48–51.

4. Hearn, *Glimpses,* 17.

5. Hearn, 23–24.

6. Nicholas Wade, "Long-Held Beliefs Are Challenged by New Human Genome Analysis," *New York Times,* February 12, 2001.

7. Wade.

8. Alfred E. Zimmern, *The Greek Commonwealth: Politics and Economics in Fifth-Century Athens* (New York: Modern Library, 1956), 209.

9. Edmund Pomeroy Collier, *Cohasset's Deep Sea Captains* (1909; repr., Cohasset, MA: Cohasset Historical Society, 1984), 44–55.

10. Gabriel García Márquez, *Love in the Time of Cholera,* trans. Edith Grossman (New York: Alfred A. Knopf, 1988), 300.

11. *Life Sharing,* 2000–2003, by Eva and Franco Mattes.

12. Robert Motherwell, "A Personal Expression," lecture delivered March 19, 1949, to the Seventh Annual Conference of the Commission on Art Education sponsored by the Museum of Modern Art, New York, in *The Writings of Robert Motherwell,* ed. Dore Ashton (Berkeley: University of California Press, 2007), 76.

13. Hendrik Hertzberg, "A Military Secret," *New Yorker,* May 7, 2001.

14. Gregory L. Vistice, "One Awful Night in Thanh Phong," *New York Times Magazine,* April 30, 2001.

15. Gianni Riotta, *Prince of the Clouds* (New York: Farrar, Straus and Giroux, 2000), 31.

16. Riotta, 35.

17. Willa Cather, *O Pioneers!* (Boston: Houghton Mifflin, 1913), 26.

18. The National Museum of Women in the Arts was incorporated in November 1981 as a private nonprofit museum. During its first five years, NMWA operated from temporary offices with docent-led tours of the collection at the Holladay residence.

19. Sun Tzu quoted in Riotta, *Prince of the Clouds,* 260–61.

20. Brenda Maddox, *Yeats's Ghosts: The Secret Life of W. B. Yeats* (New York: HarperCollins, 1999), 193.

21. Maddox, 261.

22. Jonathan Weinberg, *Intimacy and the Creative Pair* (Santa Fe, NM: Owings-Dewy Fine Art, 2001), 6.

23. Walter Pater, *The Renaissance: Studies of Art and Poetry* (Oxford: Oxford University Press, 1986), 150.

24. Pater, 40–46.

25. Michael Brenson, *Visionaries and Outcasts: The NEA, Congress, and the Place of the Visual Artist in America* (New York: New Press, 2001).

26. W. H. Auden, *The Dyer's Hand and Other Essays* (London: Faber and Faber, 1962), 73–74.

27. Jim Robbins, "A Tree Project Helps the Genes of Champions Live On," *New York Times,* July 10, 2001.

28. "From a Noxious Landfill to a Nurturing Colony for Artisans," *New York Times,* July 24, 2001.

29. Michael Specter, "Rethinking the Brain," *New Yorker,* July 23, 2001.

30. Richard Manning, "Destiny Revisits the Great Plains," *New York Times,* July 10, 2001.

31. Al Baker, "By the Sea, Writing Mothers Need Not Choose," *New York Times,* July 29, 2001.

32. Katharine Kuh, "Cantankerous Clyfford Still's Palette of Green and Black," *Washington Post,* June 17, 2001.

33. Kuh.

34. Jorge Luis Borges, *This Craft of Verse* (Cambridge, MA: Harvard University Press, 2000), 43.

35. Borges, 45.

36. William Blake, "The Little Black Boy," in *Oxford Book of English Verse,* ed. Arthur Quiller-Couch (Oxford:

Clarendon Press, 1908), 560–61.

37. Glenway Wescott, *The Grandmothers: A Family Portrait* (New York: Athenaeum, 1927), 6.

38. Clement Greenberg, "Problems of Criticism II: Complaints of an Art Critic," *Artforum,* October 1967, quoted in *Clement Greenberg: A Critic's Collection,* ed. Karen Wilkin (Princeton, NJ: Princeton University Press, 2001), 15.

39. James Glanz and Dennis Overbye, "Anything Can Change, It Seems, Even an Immutable Law of Nature," *New York Times,* August 15, 2001.

40. Nicholas Wade, "Age-Old Question Is New Again," *New York Times,* August 15, 2001.

41. Mark Glaser, "Museum Raiders," *New York Times,* August 9, 2001.

42. Anthony Bailey, *Vermeer: A View of Delft* (New York: Henry Holt, 2001), 40.

43. Marcel Proust, *The Captive* (New York: Random House, 1929), 249–50.

44. Bailey, *Vermeer,* 204.

45. Proust, *The Captive,* 250.

46. Truitt was a follower of the writings of French philosopher, paleontologist, and Jesuit priest Pierre Teilhard de Chardin, who envisioned a future state of postnationalist world unity that he described as the "planetization of mankind."

47. William L. Hamilton, "Neighbors, Shining Through; When the Nest Resists the Storm," *New York Times,* September 20, 2001.

48. *Nearer, Core,* and *Res/Things* were all working titles for what would become the series *Pith* (2001–4).

49. Amy Waldman, "With Solemn

Detail, Dust of Ground Zero Is Put in Urns," *New York Times,* October 15, 2001.

50. Leo Tolstoy, *Resurrection,* translated and with an introduction by Rosemary Edmonds (London: Penguin, 1966), 387.

51. Tolstoy, 391.

52. Tolstoy, 403.

53. Tolstoy, 447.

54. Tolstoy, 450.

55. Tolstoy, 564.

56. For this reason Truitt ultimately decided not to integrate her 1948–49 journal into the text of *Yield.*

57. William Langewiesche, "The Crash of EgyptAir 990," *Atlantic Monthly,* November 2001.

58. William Langewiesche, *Inside the Sky* (New York: Vintage, 1999), 63.

59. François Fénelon, *The Complete Fénelon,* trans. and ed. Robert J. Edmonson (Brewster, MA: Paraclete, 2008), 36.

60. James Meyer, *Minimalism: Art and Polemics in the Sixties* (New Haven: Yale University Press, 2001).

61. Arthur C. Danto, "Compare and Contrast: Minimalism's Long Haul to Artistic Correctness," *Times Literary Supplement,* October 19, 2001.

62. Michael Kimmelman, "E. H. Gombrich, Author and Theorist Who Redefined Art History, Is Dead at 92," *New York Times,* November 7, 2001.

63. Quoted in White, *Proust,* 35.

64. David Markson, *This Is Not a Novel* (Washington, DC: Counterpoint, 2001), 186.

65. Quoted in Jill Baumgaertner, *Flannery O'Connor: A Proper Scaring* (Wheaton, IL: Harold Shaw, 1988), 2.

66. Baumgaertner, 16.

67. Baumgaertner, 64.

68. *I Heard God Laughing: Poems of Hope and Joy,* renderings of Hafiz by Daniel Ladinsky (Walnut Creek, CA: Sufism Reoriented, 1996), 53.

69. Katharine Butler Hathaway, *The Little Locksmith* (New York: Feminist, 2000), 137.

Selected Chronology

1. Anne Truitt, *Daybook: The Journal of an Artist* (New York: Pantheon, 1982), 65–66.

2. Although Truitt wrote in *Daybook* that she "abandoned writing for sculpture in 1948" (43), Truitt's journal from the time indicates that she continued to pursue both writing and art-making simultaneously at least through October 6, 1949, the last entry in the journal. Box 1, folder 16, Anne Truitt Papers, Special Collections Department, Bryn Mawr College Library.

3. While Truitt recorded in *Daybook* that she took classes from Giampietro from September 1948 through December 1949 (127), her 1948–49 journal gives us the exact start date of February 8, 1949. She further elaborated in her February 4, 1949, entry that she "Registered at Inst Contemp Art to-day for sculpture. Taught by Giampietro, according to Richman a good man." Box 1, folder 16, Anne Truitt Papers, Special Collections Department, Bryn Mawr College Library.

4. Records kept by the artist account for thirty-five works dating to 1962,

including an unpainted panel, while
Truitt recalled making thirty-seven
works in *Daybook,* 153.

5. From 1963 to 1996 Truitt was repre-
sented by and regularly exhibited at
André Emmerich Gallery.

6. Donald Judd, "In the Galleries: Anne
Truitt," *Arts Magazine* 37, no. 8 (April
1963): 61; James Meyer, *Minimalism*
(London: Phaidon, 2000), 194.

yalebooks.com/art

Designed by Katy Nelson for Joseph Logan Design
Set in Dover, designed by Robin Mientjes
Typeset by Katy Nelson
Printed in the United States by Sheridan

Library of Congress Control Number: 2021934203
ISBN 978-0-300-26040-3
eISBN 978-0-300-26432-6

A catalogue record for this book is available from the British Library.

This paper meets the requirements of ANSI/NISO Z 39.48-1992
(Permanence of Paper).
10 9 8 7 6 5 4 3 2 1
Jacket illustration: Anne Truitt, *Sound Ten*, 2003. Acrylic on paper, 19½ × 19½ in.
(50 × 50 cm). Courtesy of Matthew Marks Gallery.